HOW TO DRAW MANGA

GIANT ROBOTS

Table of Contents

HOW TO DRAW MANGA: Giant Robots
by Hikaru Hayashi, Go Office

First published in 2001 by Graphic-sha Publishing Co., Ltd.
This English edition was published in 2001 by
Graphic-sha Publishing Co., Ltd.
1-9-12 Kudan-kita, Chiyoda-ku, Tokyo 102-0073 Japan

Drawing and production: Nariaki Funabori, Kazuaki Morita, Kouichi Kusano, Hajime Yoshida,
 Takehiko Matsumoto, Hikaru Hagizuki, Choujikuuajari
Cover drawing and coloring: Yukiharu Akimoto, Kouichi Kusano
Scenario and composition: Hikaru Hayashi
Original cover design: Eiji Co., Ltd.
Japanese edition editor: Motofumi Nakanishi (Graphic-sha Publishing Co., Ltd.)
English edition editor: Glenn Kardy (Japanime Co., Ltd.)
English edition cover and layout: Shinichi Ishioka
English translation management: Língua fránca, Inc. (an3y-skmt@asahi-net.or.jp)
Foreign language edition project coordinator: Kumiko Sakamoto (Graphic-sha Publishing Co., Ltd.)

Distributed by
Japanime Co., Ltd.
2-8-102 Naka-cho, Kawaguchi-shi,
Saitama 332-0022, Japan
Phone/Fax: +81-48-259-3444
E-mail: sales@japanime.com
http://www.japanime.com

First printing: August 2001

ISBN: 4-7661-1255-5
Printed and bound in China by Everbest Printing Co., Ltd.

Section 1
Basic Robot Design

Full Body Start with a Human-shaped Figure

Think of the parts of the body when drawing.

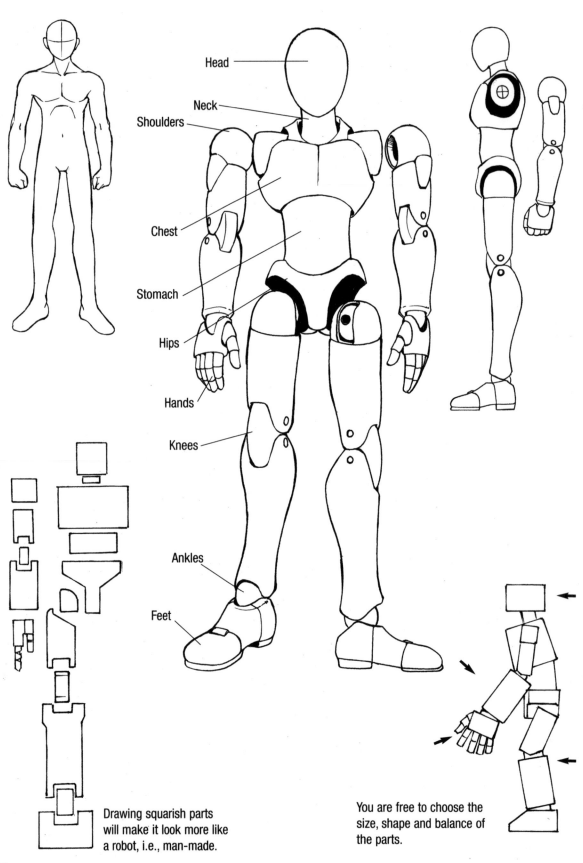

Head

Neck

Shoulders

Chest

Stomach

Hips

Hands

Knees

Ankles

Feet

Drawing squarish parts will make it look more like a robot, i.e., man-made.

You are free to choose the size, shape and balance of the parts.

Draw Robot-like Figures Using Only Basic Parts.
- Draw big, bold joints.
- Give the surface a strong metallic contrast.

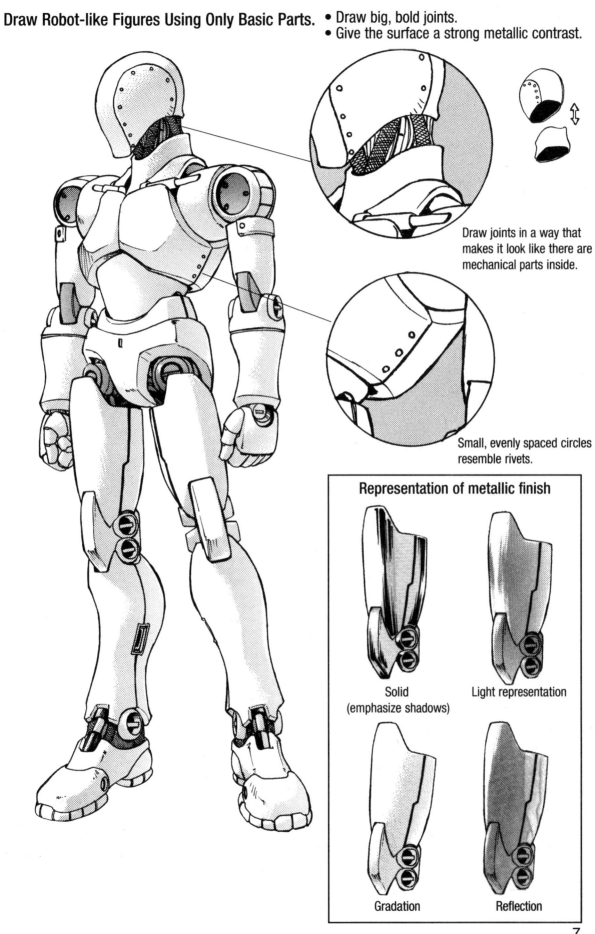

Draw joints in a way that makes it look like there are mechanical parts inside.

Small, evenly spaced circles resemble rivets.

Representation of metallic finish

Solid
(emphasize shadows)

Light representation

Gradation

Reflection

A square part becomes a metallic-looking cube when the corners are rounded off.

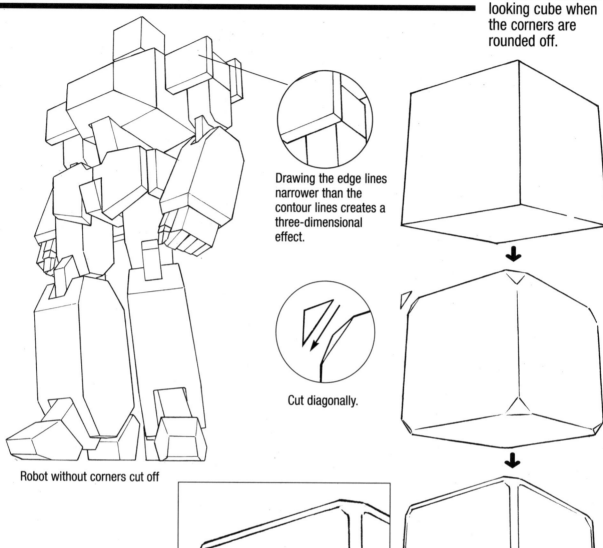

Drawing the edge lines narrower than the contour lines creates a three-dimensional effect.

Cut diagonally.

Robot without corners cut off

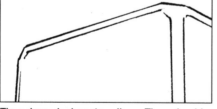

Then draw dual contour lines. They should be close together. This helps represent the shine of a smooth metallic edge.

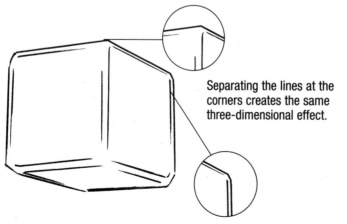

Separating the lines at the corners creates the same three-dimensional effect.

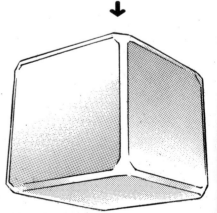

Example of finished block. Apply tone and plane.

This robot was drawn by selectively removing corners and using dual contour lines. Tones were applied to accent the metallic feel of the surface.

The trick is to apply tones to only about 50% of the surface, leaving the other half white, thus creating a shining effect.

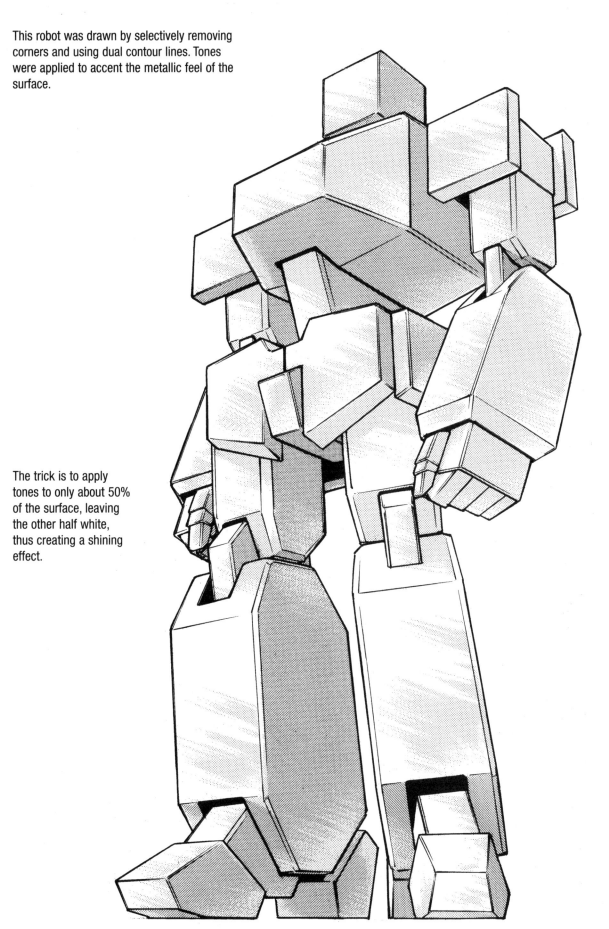

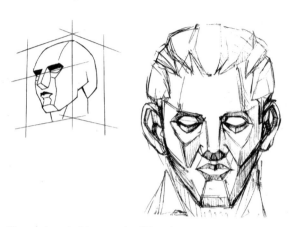

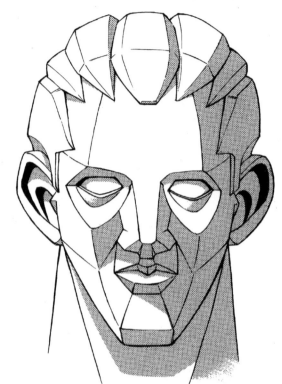

Since a beveled image simplifies the unevenness of the face/head and is blockish, it is easy to apply this effect to a robot head by making the lines sharp and giving it a metallic quality.

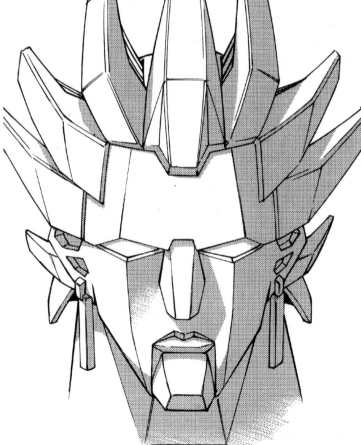

You can effectively express a metal-like cubic effect by using double lines for the edges of the part of the head signifying the hair.

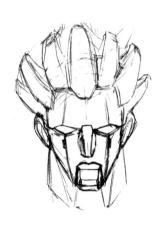

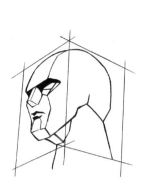

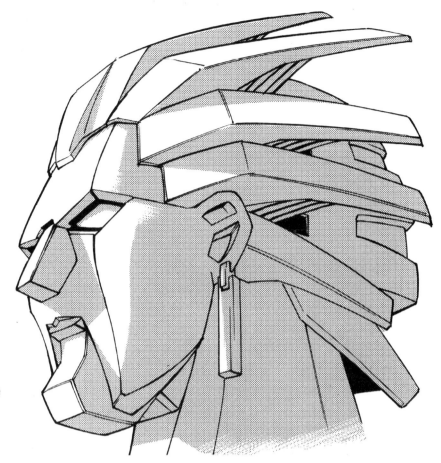

You can make it look like removable armor is covering the face of a robot by making some lines bold and some thin.

Heaviness and a robot-like molded feel are created when you make some of the movable parts solid.

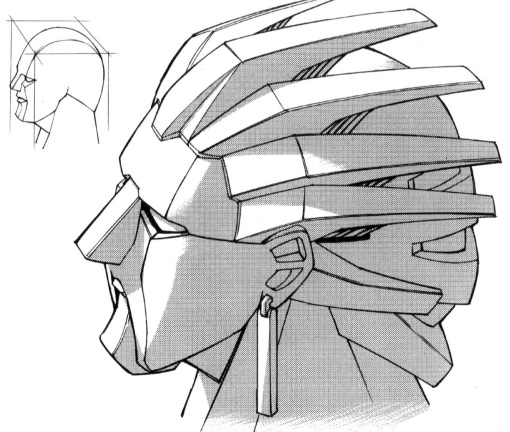

Head | Replacement and Omission

Replace the eyes, ears, nose and mouth with mechanical parts.

Omission of Face Parts

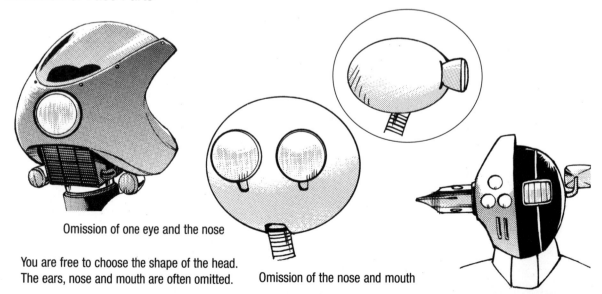

Omission of one eye and the nose

You are free to choose the shape of the head. The ears, nose and mouth are often omitted.

Omission of the nose and mouth

Asymmetrical

Replacement of the Head Itself

Use everyday objects to give your robot an unexpectedly familiar face.

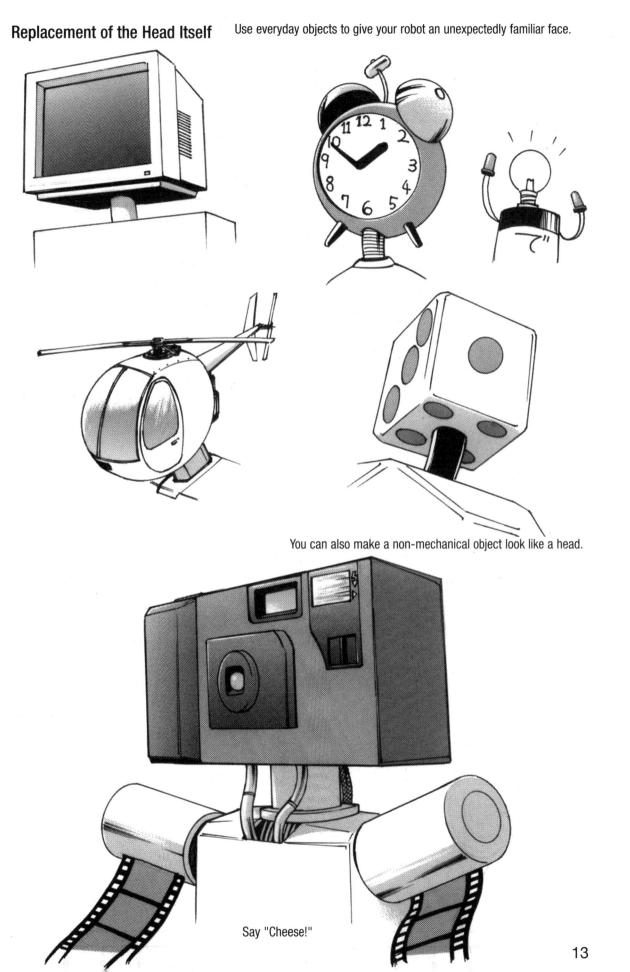

You can also make a non-mechanical object look like a head.

Say "Cheese!"

Head | Eye Shape and Size

The eyes are based on three basic shapes: triangles, squares and circles.

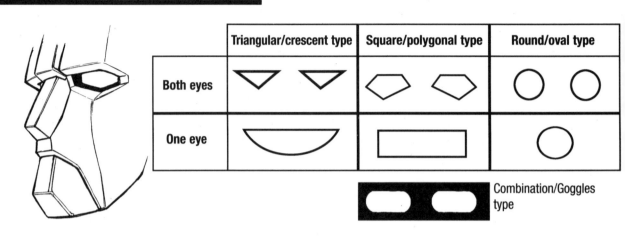

	Triangular/crescent type	Square/polygonal type	Round/oval type
Both eyes	▽ ▽	⬠ ⬠	◯ ◯
One eye	⌣	▭	⬭

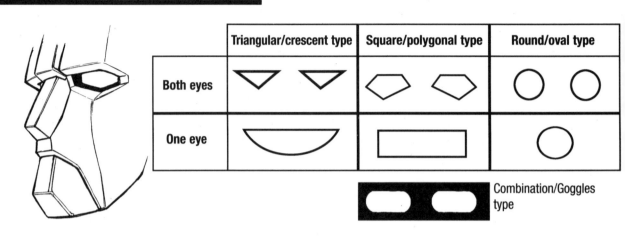

Combination/Goggles type

Mechanical Eyes

Goggles type

Plate glass type

Straight line

Spherical-lens type

Curved line

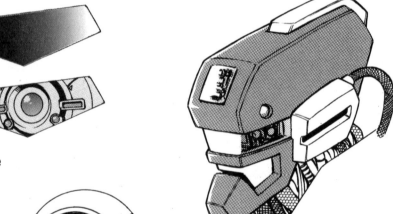

For the round-lens type, you should draw an entire eyeball.

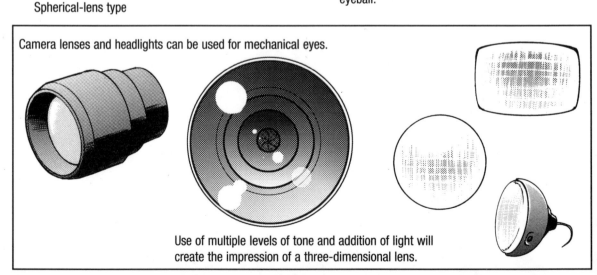

Camera lenses and headlights can be used for mechanical eyes.

Use of multiple levels of tone and addition of light will create the impression of a three-dimensional lens.

Polygonal type

Round type

Rectangular type

Concave type

Convex type

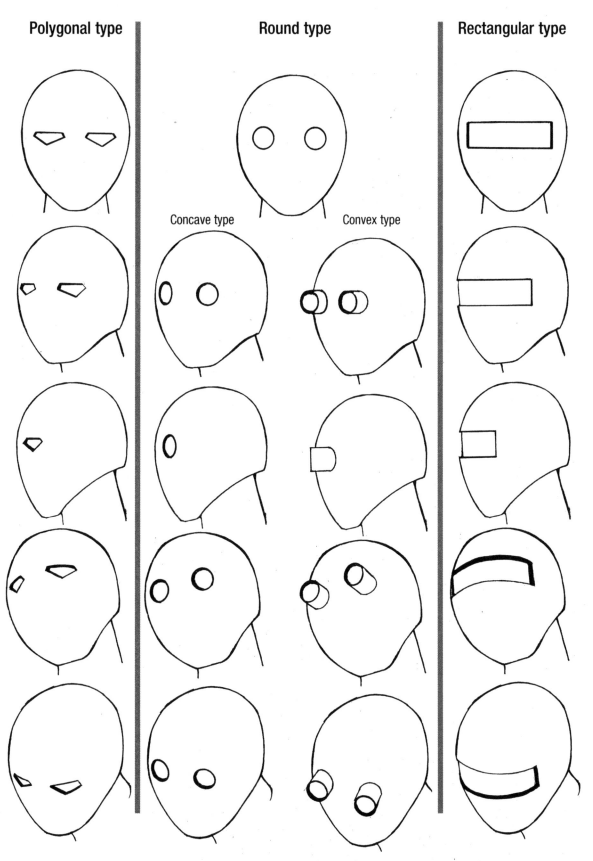

Decide whether the eyes are concave or convex.

There are two general approaches to drawing a robotic mouth: One is to consider the shape formed by the lines that connect the nose and mouth, while the other is to view the mouth in relationship to the overall structure of the head.

Design Based on Shape

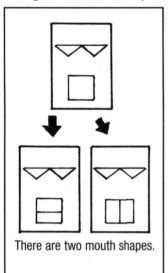

There are two mouth shapes.

Clearly establish whether the mouth is concave or convex.

Simplification

The lines connecting the nose and mouth are key to the design.

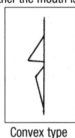
Convex type

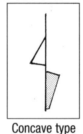
Concave type

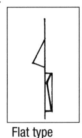
Flat type

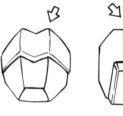

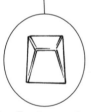

Front example

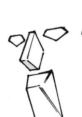

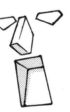

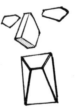

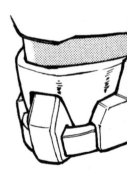

Other mouth designs

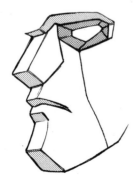

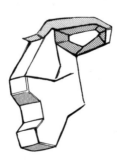

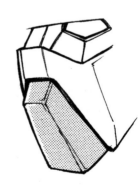

Design Based on Structure

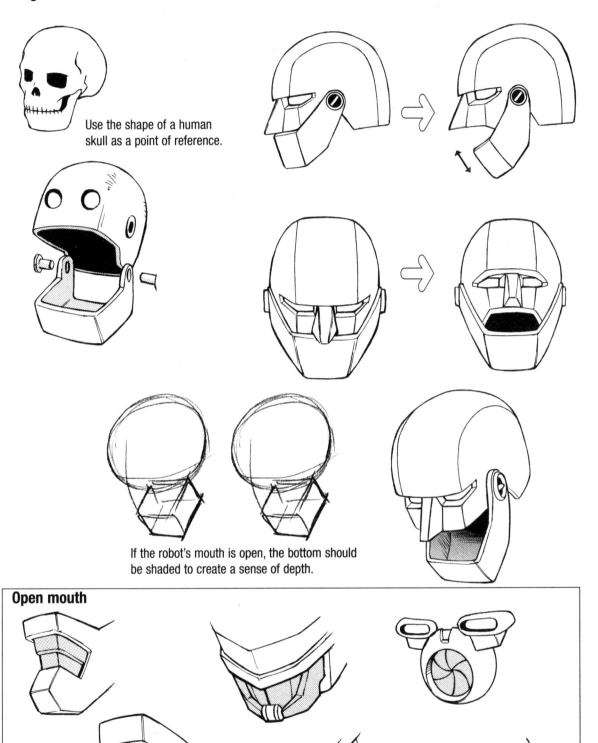

Use the shape of a human skull as a point of reference.

If the robot's mouth is open, the bottom should be shaded to create a sense of depth.

Open mouth

Shutter type
(moves up and down)

Door type
(moves left and right)

Circular shutter type
(opens and closes like a camera lens)

Head | Nose and Ears

Design the nose and ears based on basic beveled shapes. Or, don't draw them at all; professional manga artists often omit the nose and ears altogether.

 Triangular nose

 Rectangular nose

 Inverted-triangular nose

Front view

Side view

 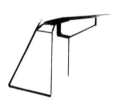 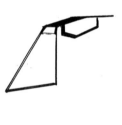

Upward view

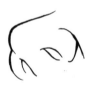 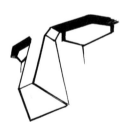 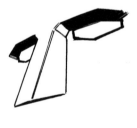 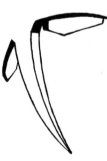

Downward view

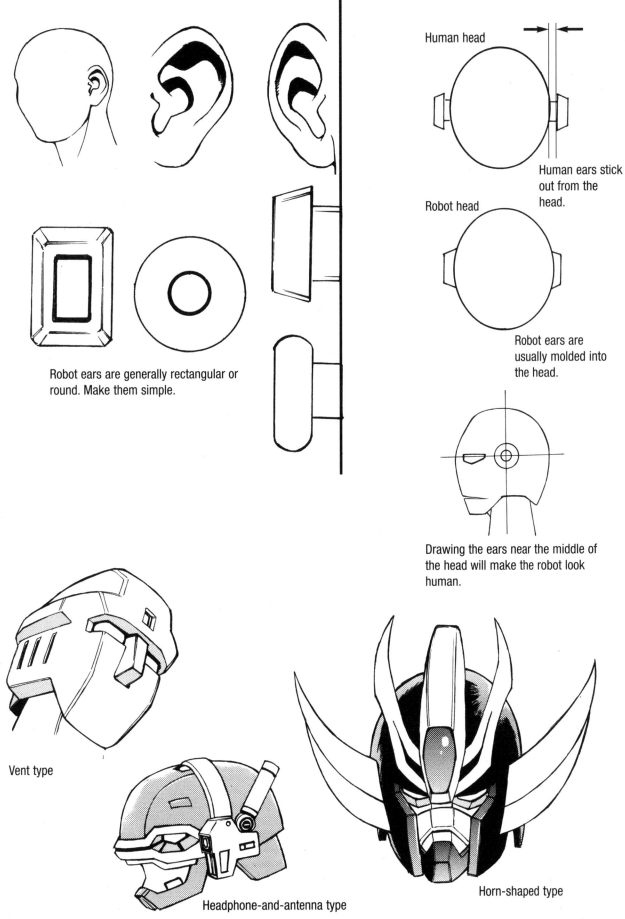

Robot ears are generally rectangular or round. Make them simple.

Human head

Human ears stick out from the head.

Robot head

Robot ears are usually molded into the head.

Drawing the ears near the middle of the head will make the robot look human.

Vent type

Headphone-and-antenna type

Horn-shaped type

Think in terms of how the neck supports the head.

Shaft- and Hinge-type Necks

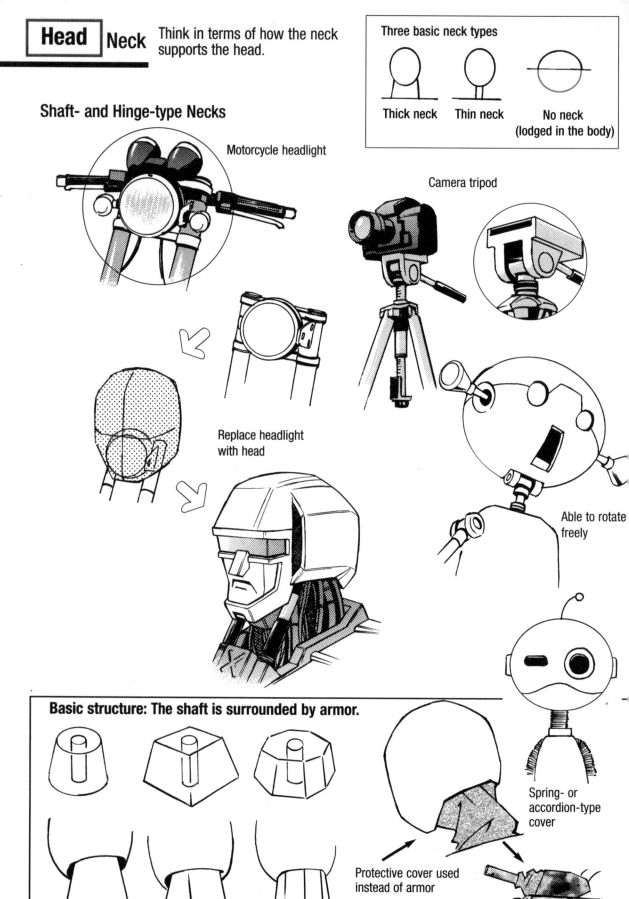

Motorcycle headlight

Camera tripod

Replace headlight with head

Able to rotate freely

Basic structure: The shaft is surrounded by armor.

Spring- or accordion-type cover

Protective cover used instead of armor

Cable- and Hose-type Necks

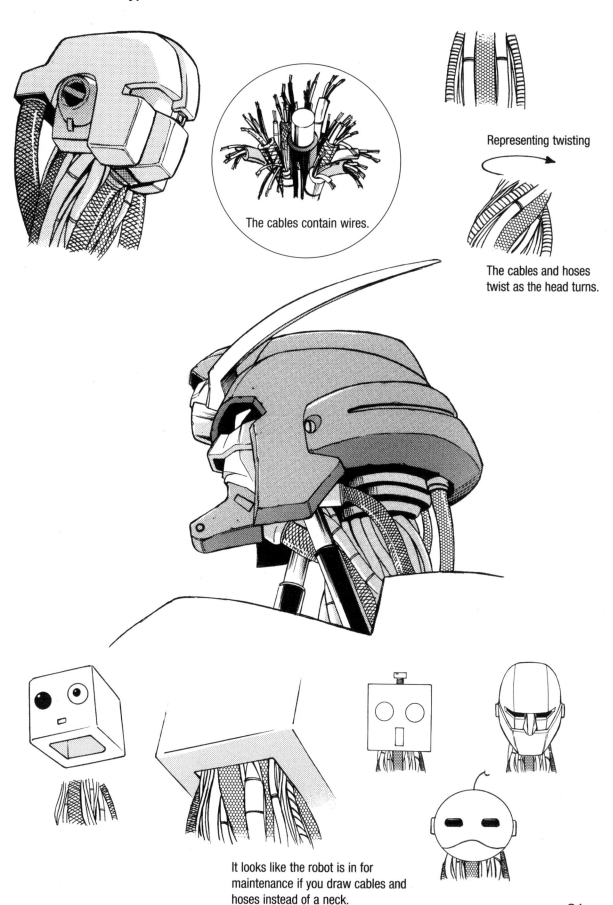

The cables contain wires.

Representing twisting

The cables and hoses twist as the head turns.

It looks like the robot is in for maintenance if you draw cables and hoses instead of a neck.

21

Trunk | Body Basics

The trunk can be a single part combining the chest, stomach and hips, or two or more separate parts.

Single-part type — Three basic shapes

Cylindrical body

Box-shaped body

Board-shaped body

The special "centipede-type" body consists of multiple parts.

Two-part type

Chest part
Four basic shapes

Inverted triangle

Stand

Oval

Square

Hips part
Three basic shapes

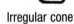

Briefs type

T type

I type

The I type is the skeleton of the briefs type and a simplified version of the T type.

Chest Patterns

Inverted triangle type

When designing the body of a robot, think about the shape as seen from the side as well as the front. A robot can have a totally different look depending on the thickness even if the design and shape look the same from the front.

Side view

Irregular cone

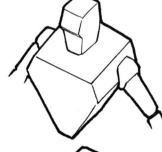

Normal box

Board

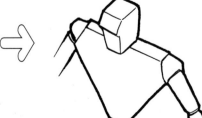

22

The Art of Design

1. Choose body type.

2. Attach arms and legs of your choice.

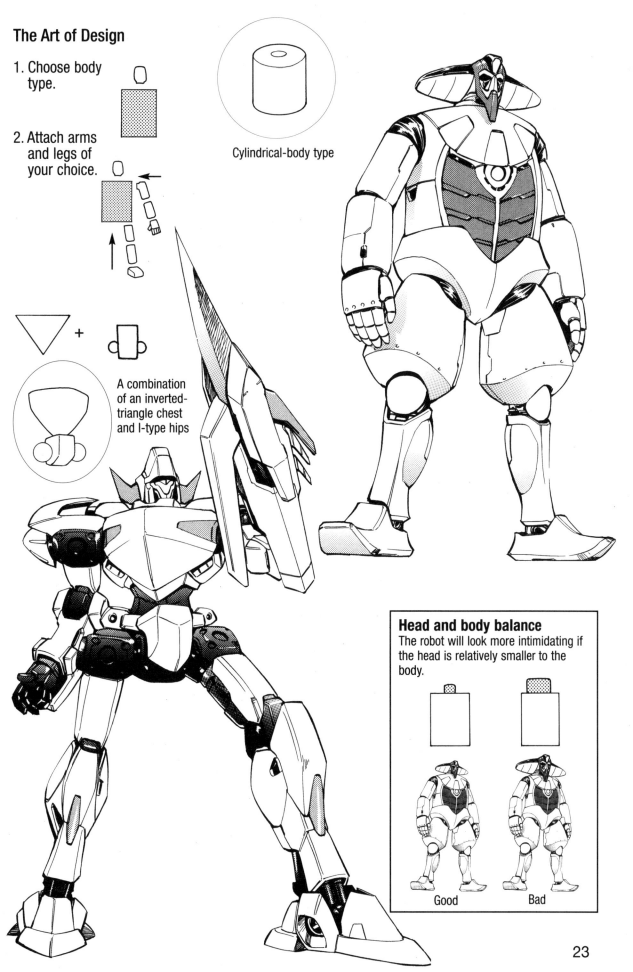

Cylindrical-body type

A combination of an inverted-triangle chest and I-type hips

Head and body balance
The robot will look more intimidating if the head is relatively smaller to the body.

Good

Bad

Trunk | Type 1: Cylindrical Body

This is the classic "potbellied" robot. It is easy to draw stocky, solid robots using this shape.

Draw three views of your robot since they are often drawn from a variety of angles.

Location of arm

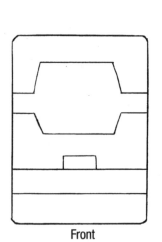

Front

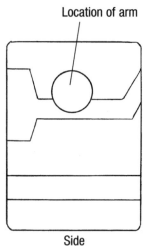

Side

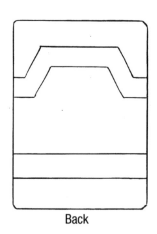

Back

Location of head

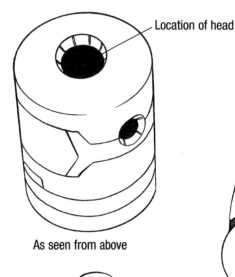

As seen from above

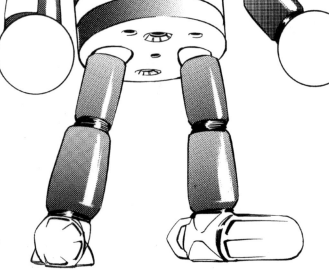

Carefully choose the locations of the arms and legs so they will look natural yet strong when the robot is viewed from the ground up.

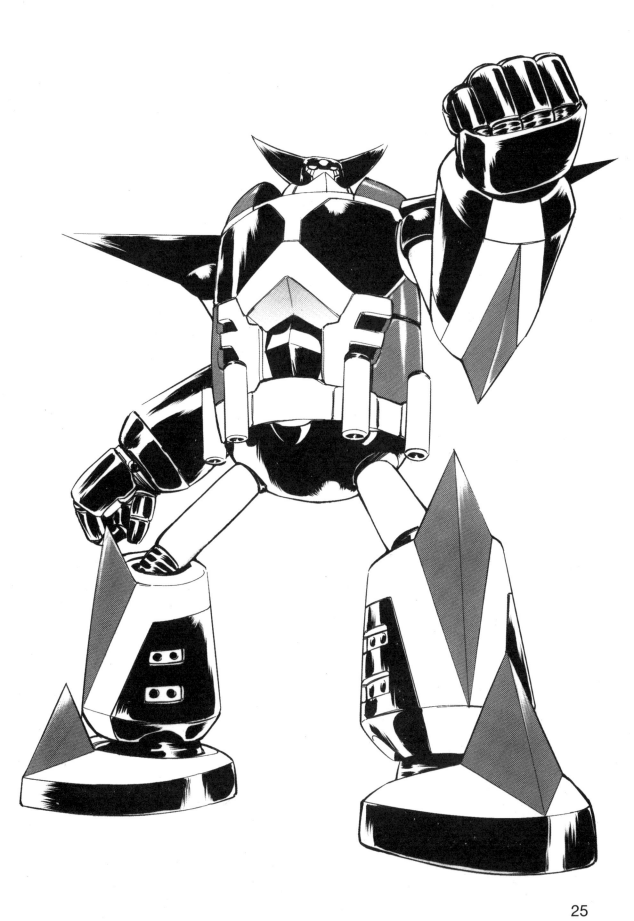

Cylindrical Body Variations

Robots with short or thin trunks look more intimidating than those with stocky ones.

Long-trunk type: thin inverted triangle

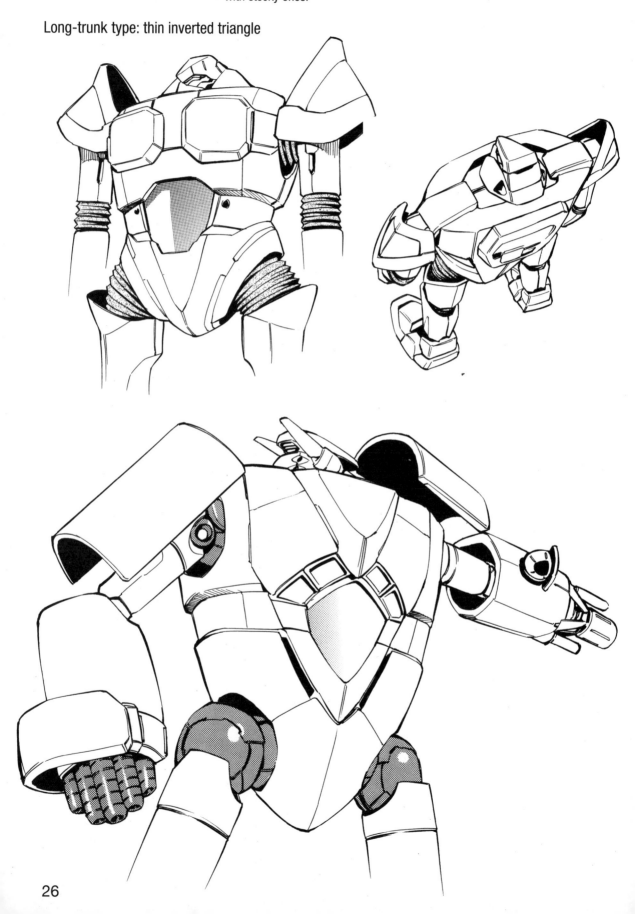

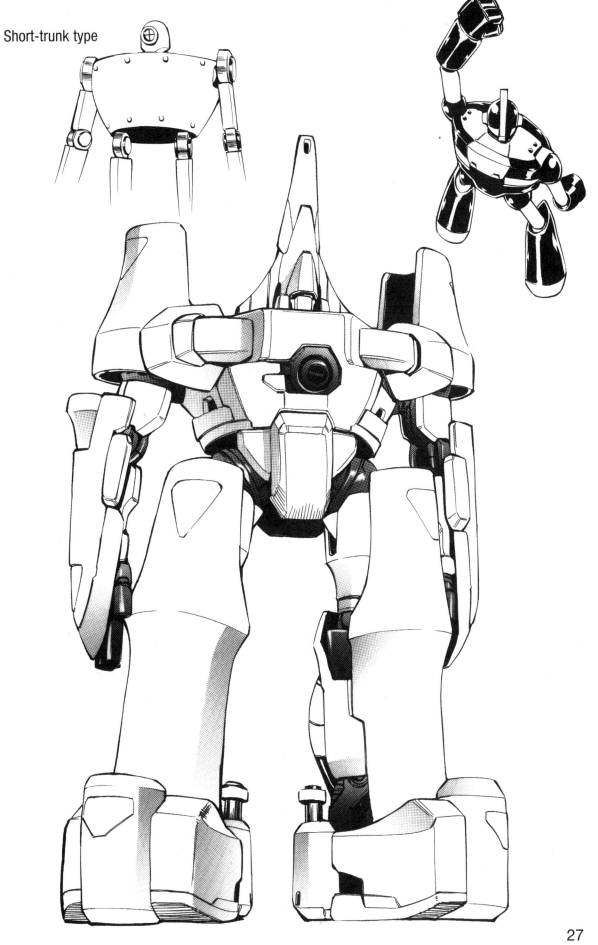

Short-trunk type

Type 2: Box-shaped Body

The box type tends to be simple, which makes it easy to draw a robot that looks heavy.

Front

Side

Back

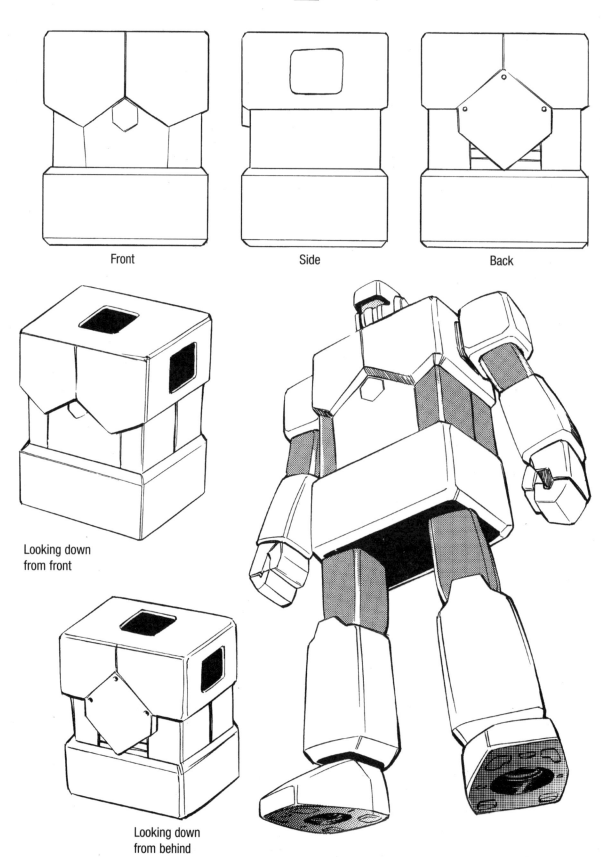

Looking down from front

Looking down from behind

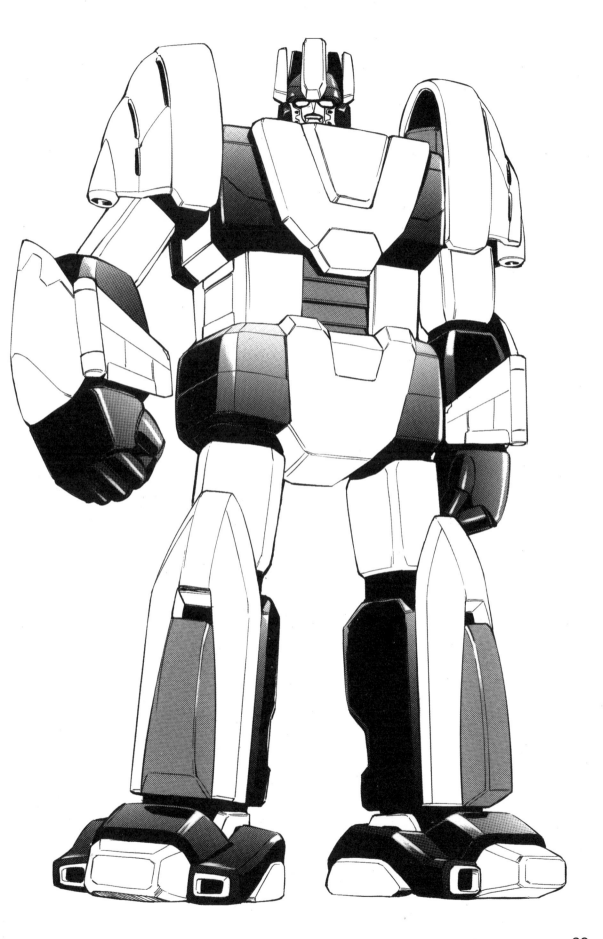

Box-shaped Body Variations Use a powerful composition since it is easy to draw in perspective.

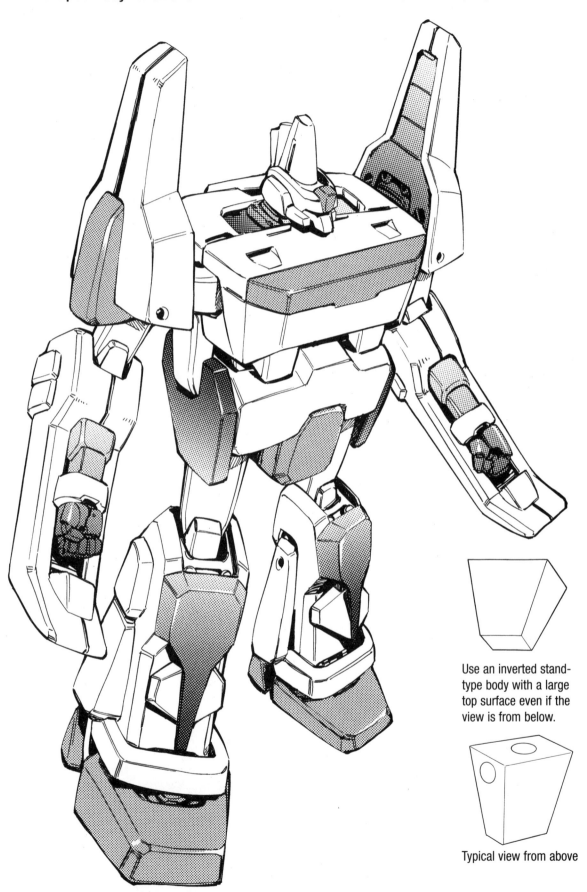

Use an inverted stand-type body with a large top surface even if the view is from below.

Typical view from above

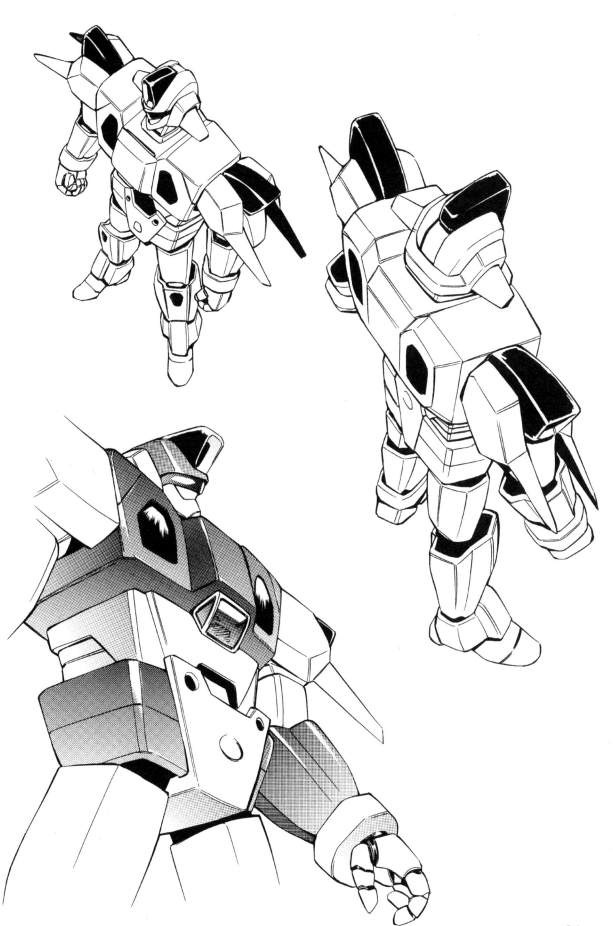

Trunk | Type 3: Board-shaped Body

Attempt to make the most of this thin type by making it sharp while also thinking about adding unevenness.

Front

Side

Back

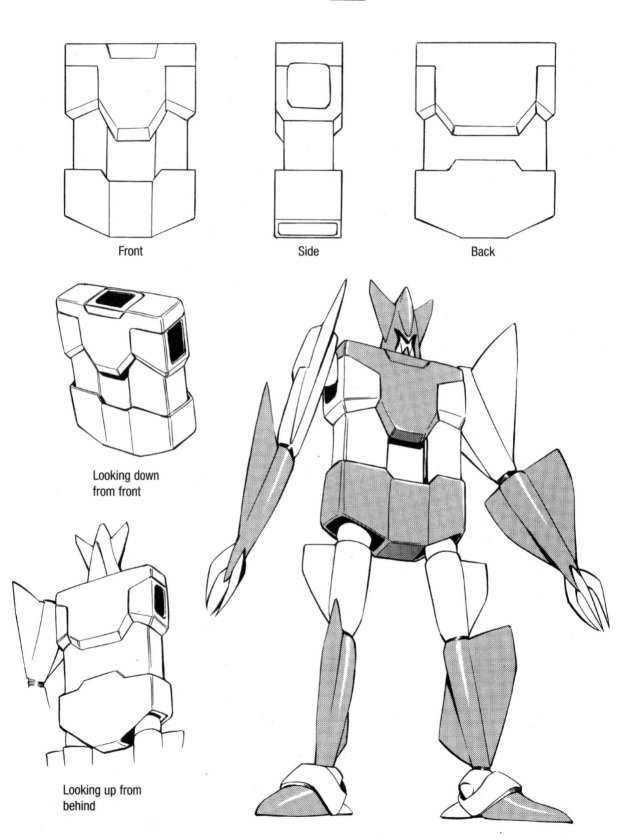

Looking down from front

Looking up from behind

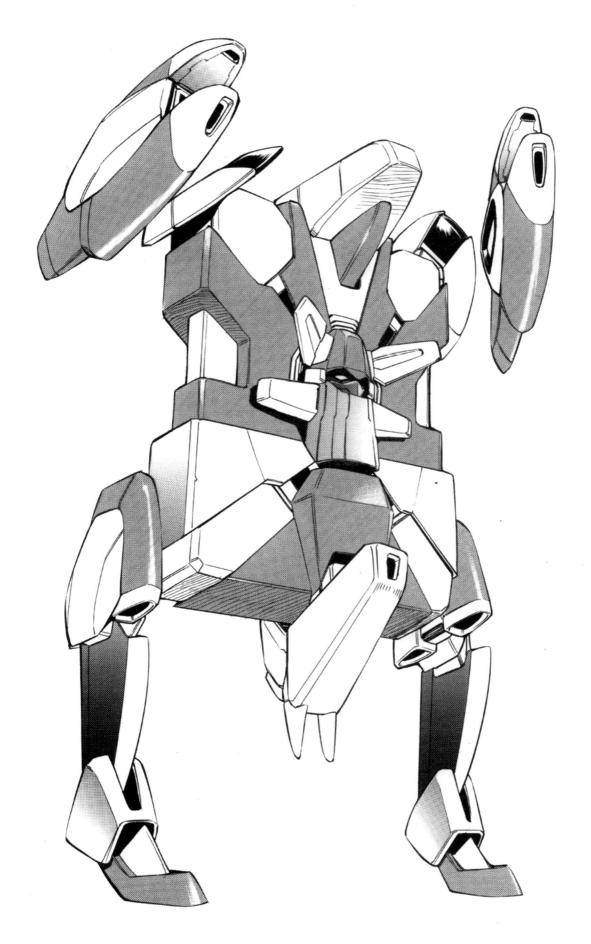

Board-shaped Body Variations

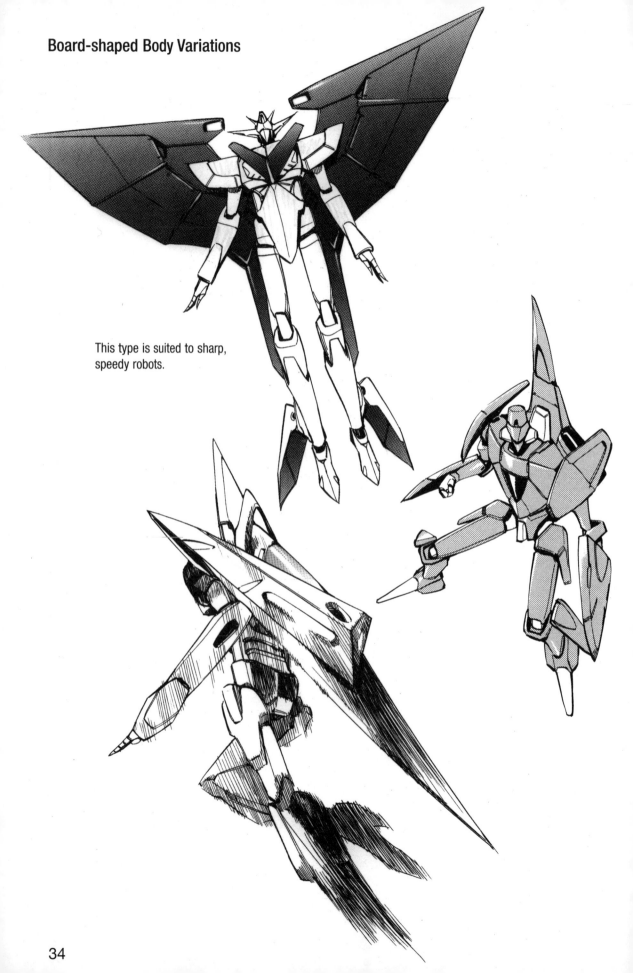

This type is suited to sharp,
speedy robots.

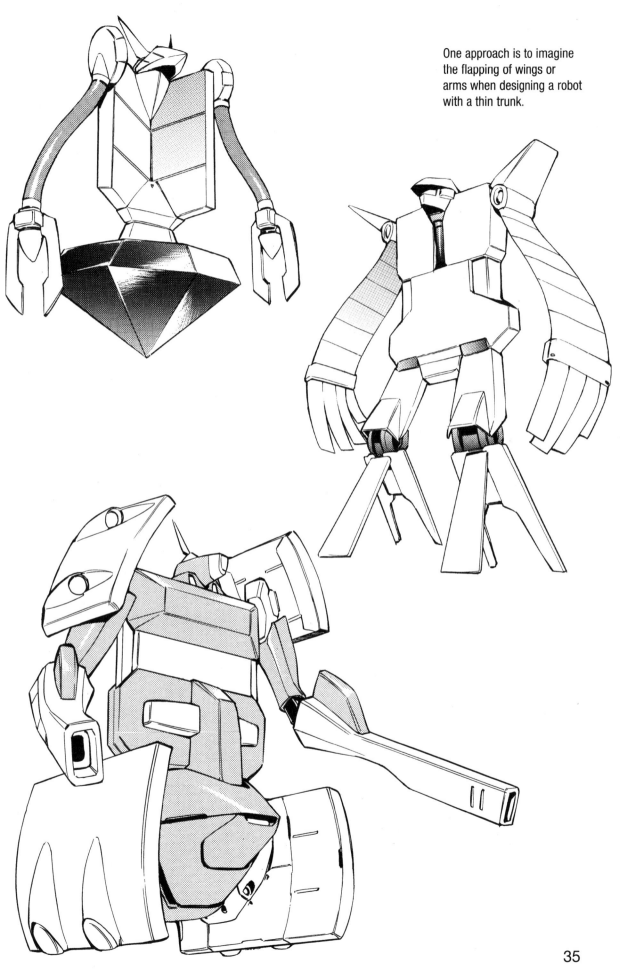

One approach is to imagine
the flapping of wings or
arms when designing a robot
with a thin trunk.

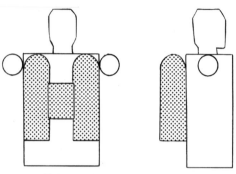

Flying device such as a jet pack

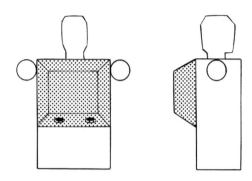

Weapons, fuel tanks, etc.

Basic Components of Transformable Robots

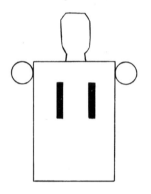

Mechanical docking type

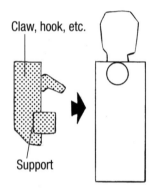

Claw, hook, etc.

Support

Choose parts that complement the body type.

A simple back that looks like nothing is there

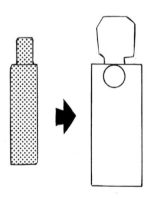

Part with the same surface as the back

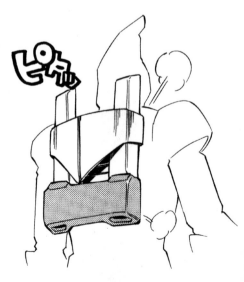

Attachable Units

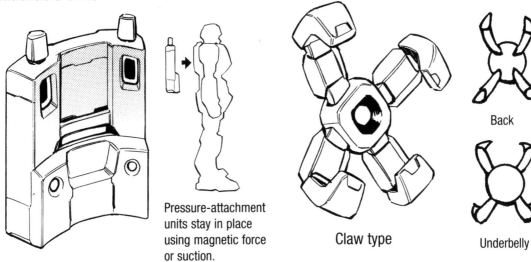

Pressure-type attachment

Pressure-attachment units stay in place using magnetic force or suction.

Claw type

Back

Underbelly

Example of claw-type attachment

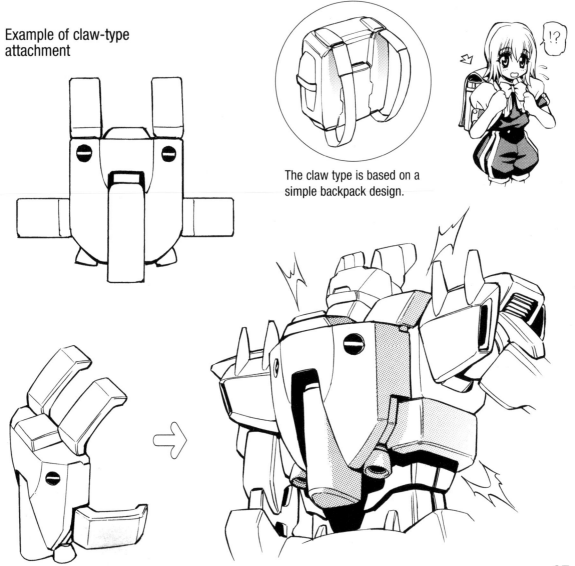

The claw type is based on a simple backpack design.

Chest Part 1: Inverted-triangle Type

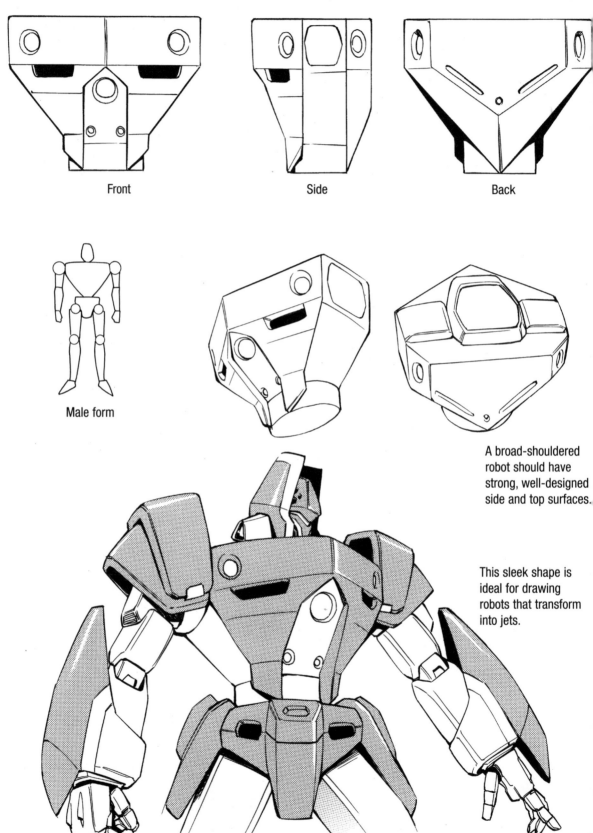

Front

Side

Back

Male form

A broad-shouldered robot should have strong, well-designed side and top surfaces.

This sleek shape is ideal for drawing robots that transform into jets.

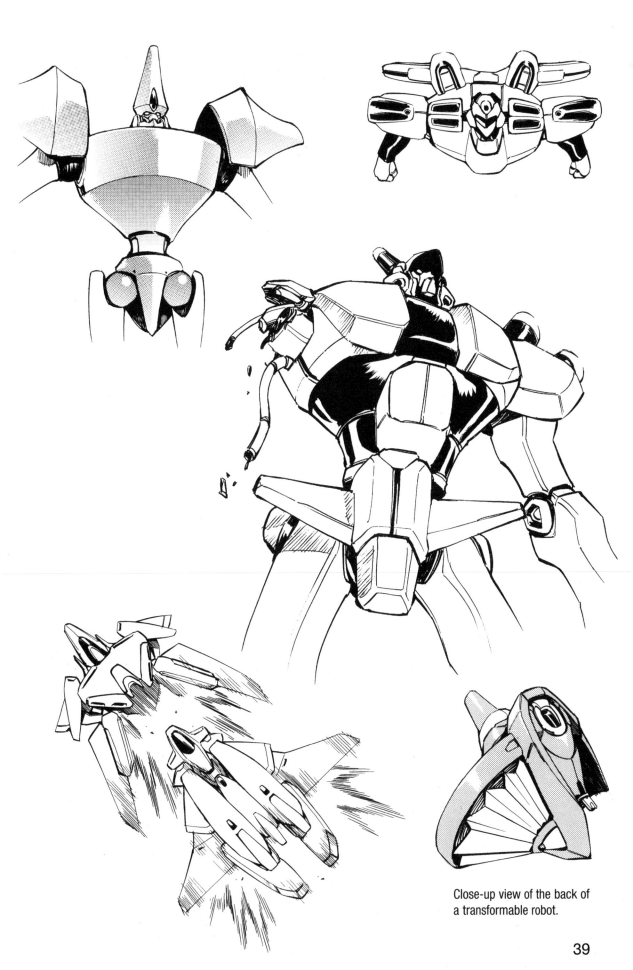

Close-up view of the back of
a transformable robot.

This shape is suited to tank-type robots and other special robot designs.

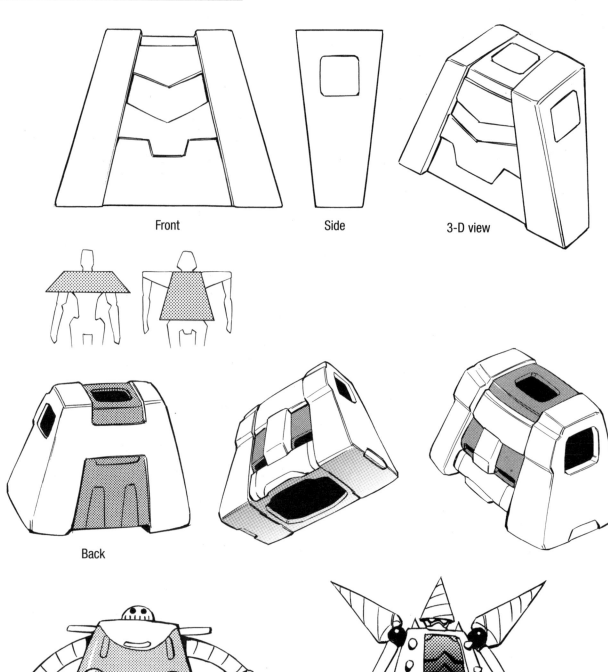

Front

Side

3-D view

Back

The stand-type chest enhances the originality of the lower body.

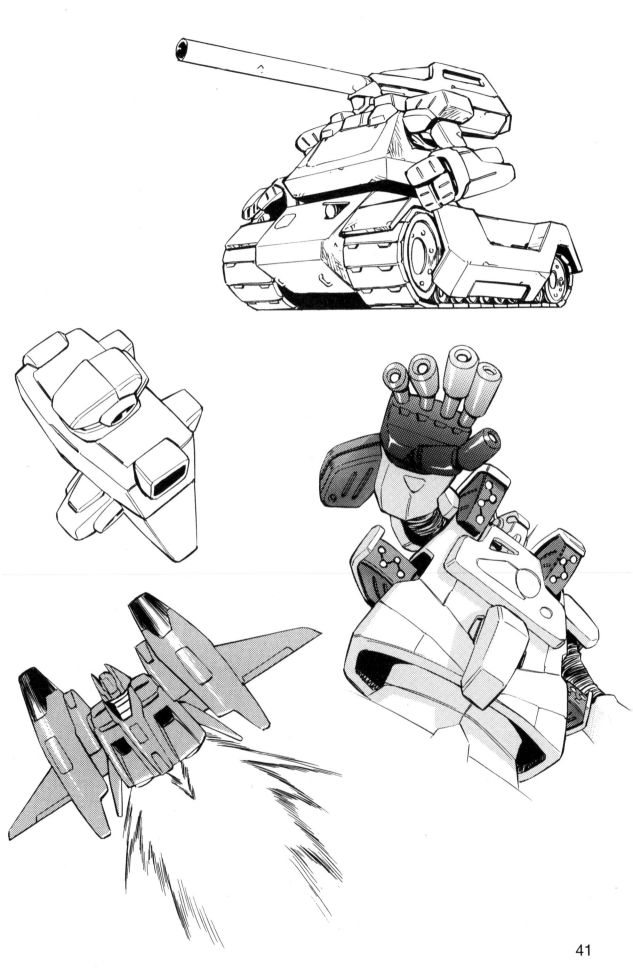

Part 3: Spherical Type

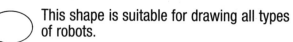

This shape is suitable for drawing all types of robots.

Front

Side

Back

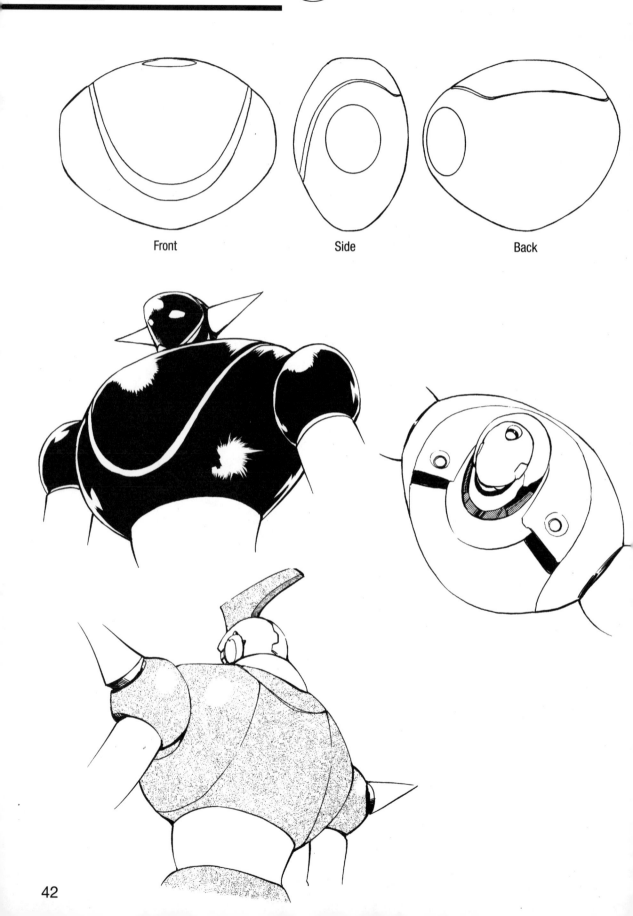

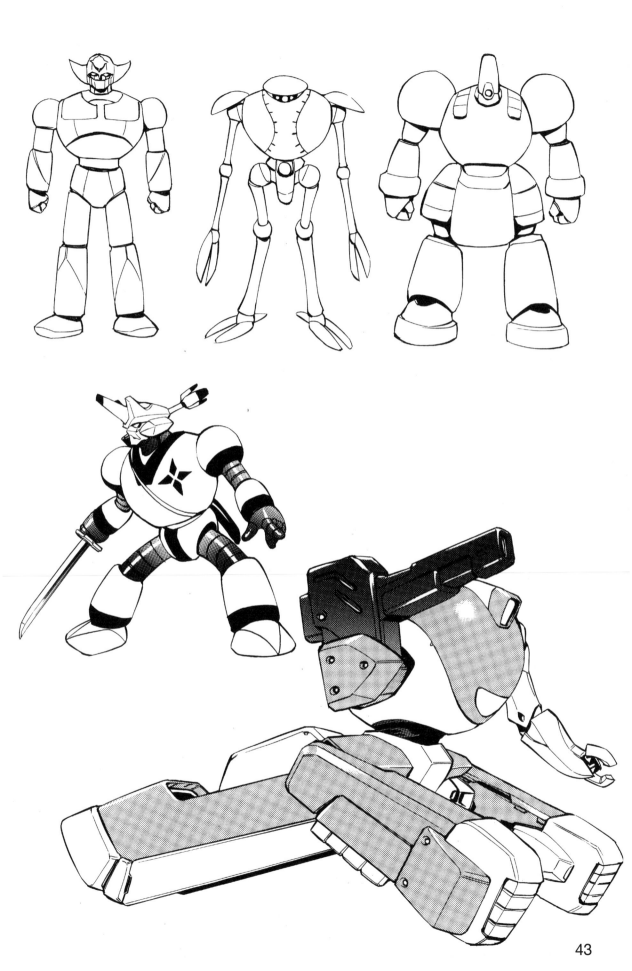

It is easy to attach a variety of parts and optional equipment to a square-shaped chest.

Front

Side

Back

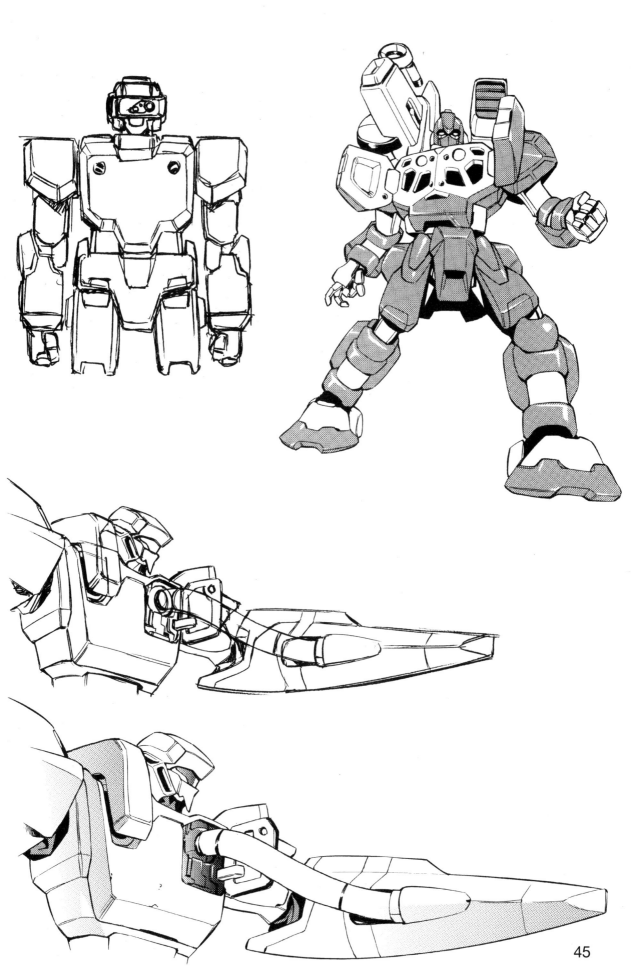

Tends to be comical. Suited to manga-type robots rather than realistic robots.

Straight-line Composition/Angular Type

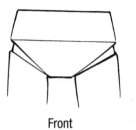

Front

Side

Bottom

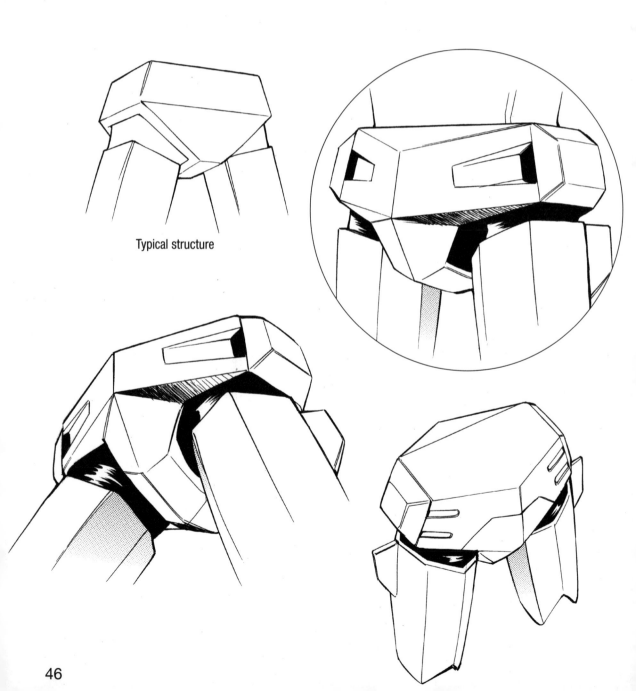

Typical structure

Curved-surface Composition/Spherical Type

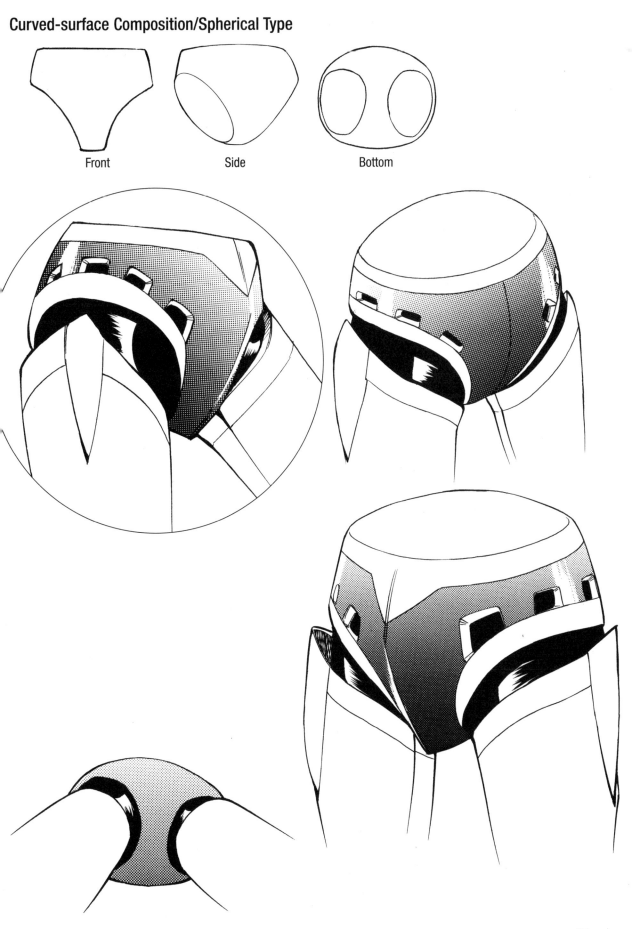

Front

Side

Bottom

Hips Part 2: T Type

This type is ideal for drawing combat robots.

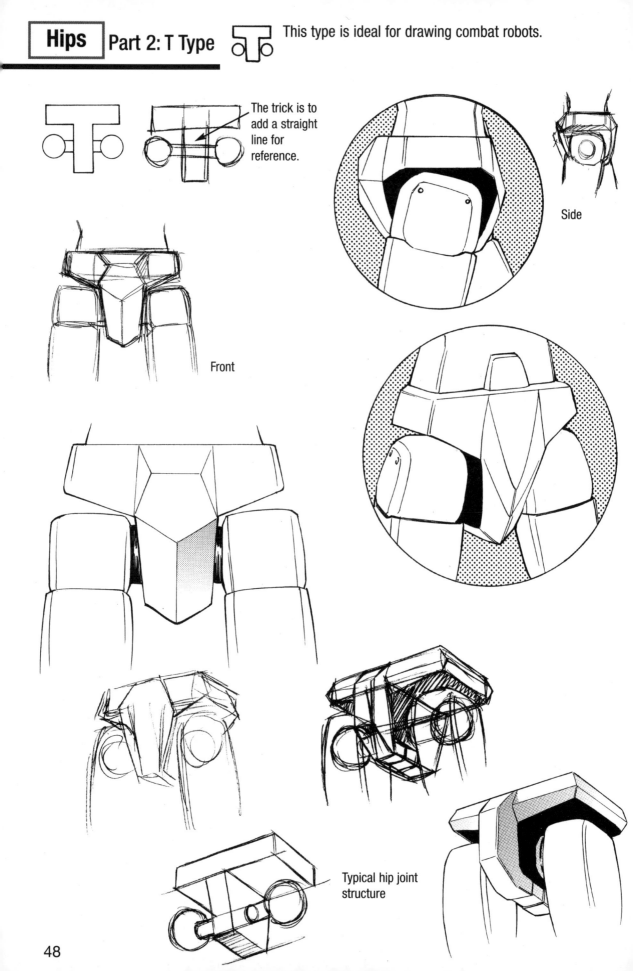

The trick is to add a straight line for reference.

Side

Front

Typical hip joint structure

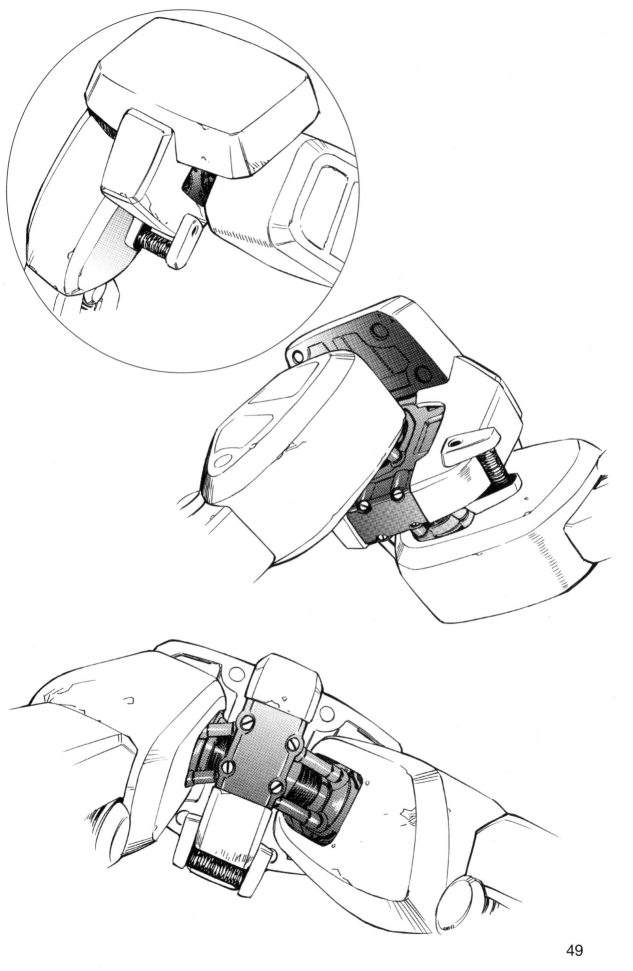

T Hip Joint Variations

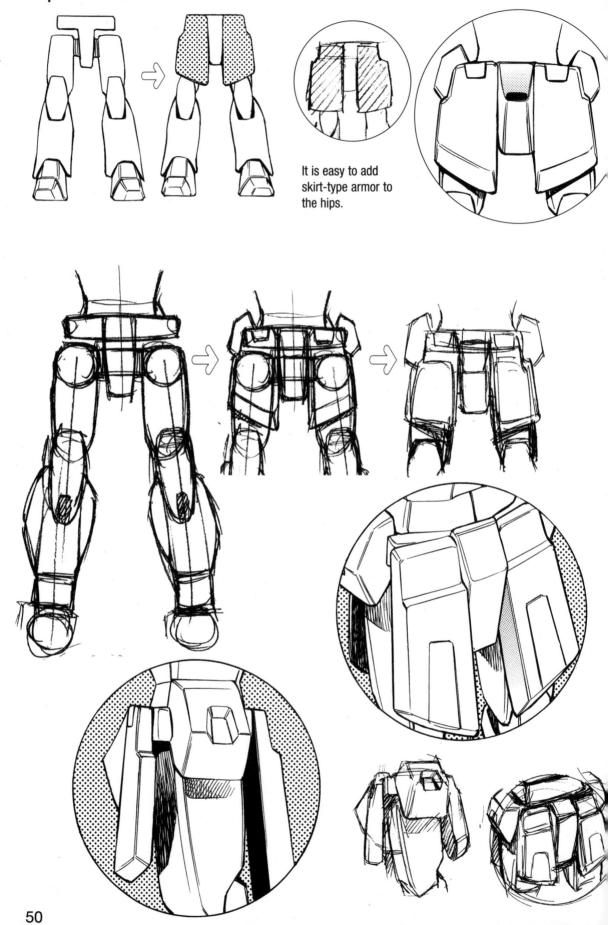

It is easy to add skirt-type armor to the hips.

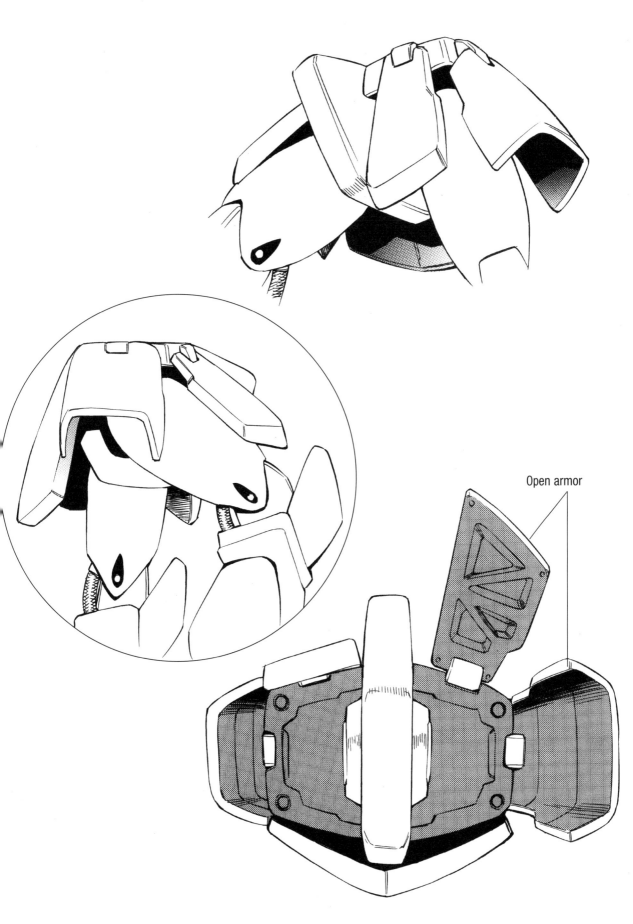

Open armor

51

Trunk | Special Body/Centipede Type

Use this body type to design original, unique robots.

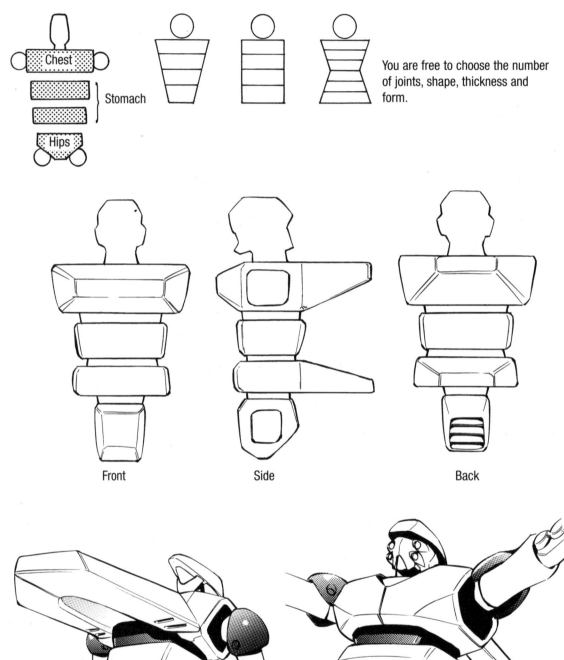

Chest

Stomach

Hips

You are free to choose the number of joints, shape, thickness and form.

Front

Side

Back

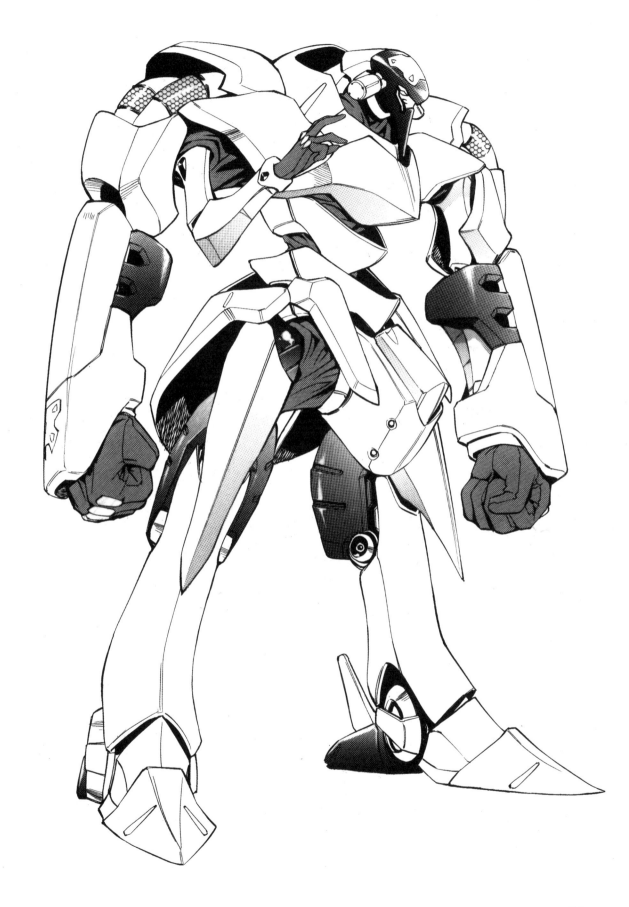

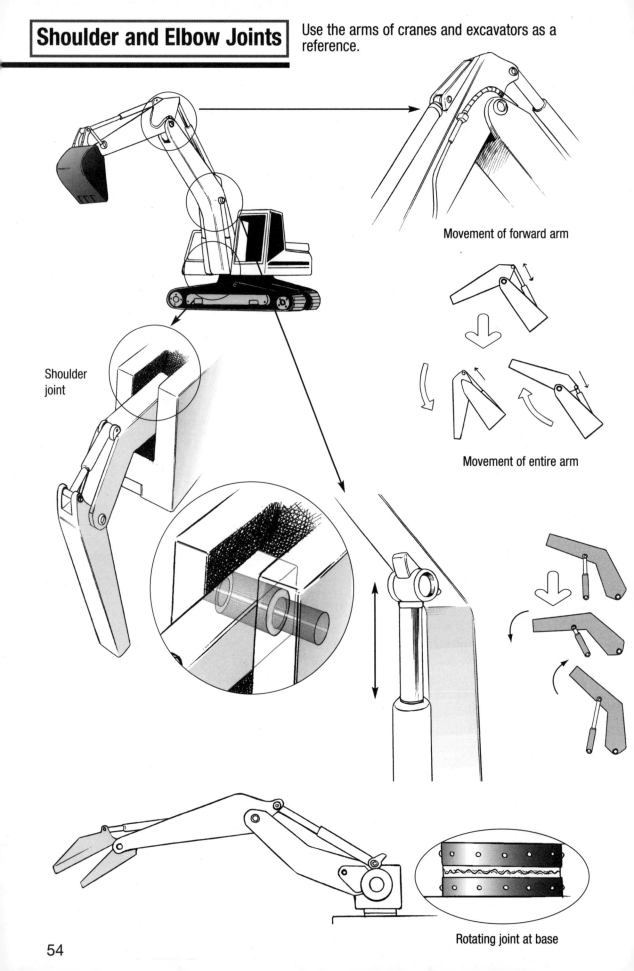

Shoulder and Elbow Joints

Use the arms of cranes and excavators as a reference.

Movement of forward arm

Movement of entire arm

Shoulder joint

Rotating joint at base

Arm Forms
They are based on prisms and cylinders.

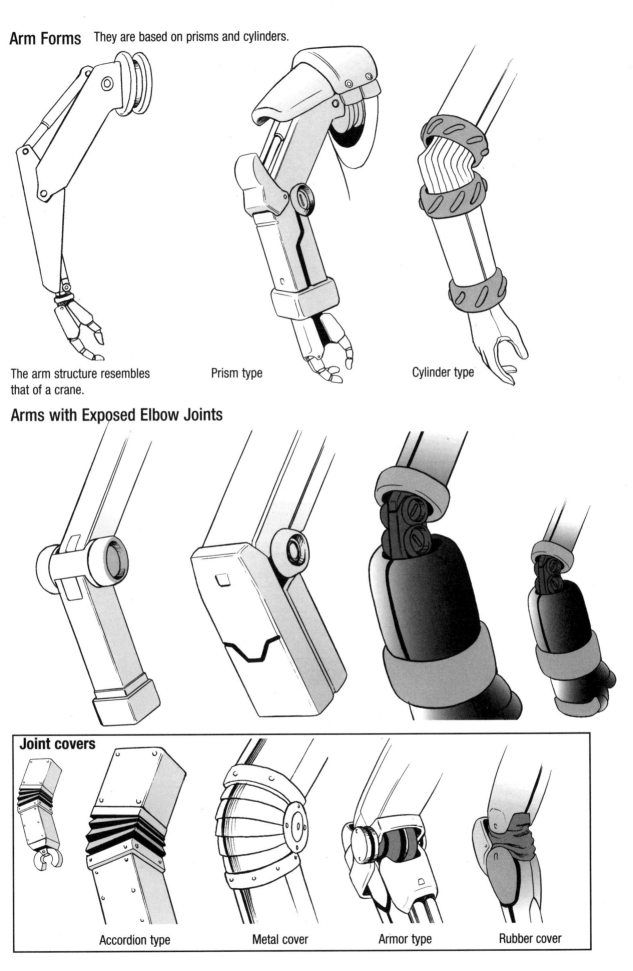

The arm structure resembles that of a crane.

Prism type

Cylinder type

Arms with Exposed Elbow Joints

Joint covers

Accordion type

Metal cover

Armor type

Rubber cover

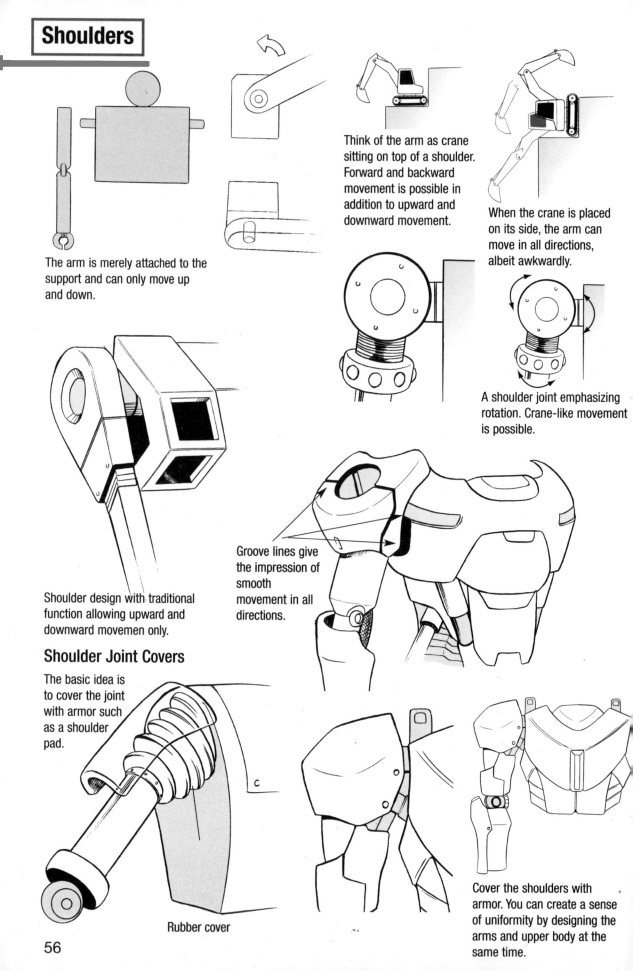

Shoulders

The arm is merely attached to the support and can only move up and down.

Think of the arm as crane sitting on top of a shoulder. Forward and backward movement is possible in addition to upward and downward movement.

When the crane is placed on its side, the arm can move in all directions, albeit awkwardly.

A shoulder joint emphasizing rotation. Crane-like movement is possible.

Shoulder design with traditional function allowing upward and downward movemen only.

Groove lines give the impression of smooth movement in all directions.

Shoulder Joint Covers

The basic idea is to cover the joint with armor such as a shoulder pad.

Rubber cover

Cover the shoulders with armor. You can create a sense of uniformity by designing the arms and upper body at the same time.

Shoulder Pads/Armor

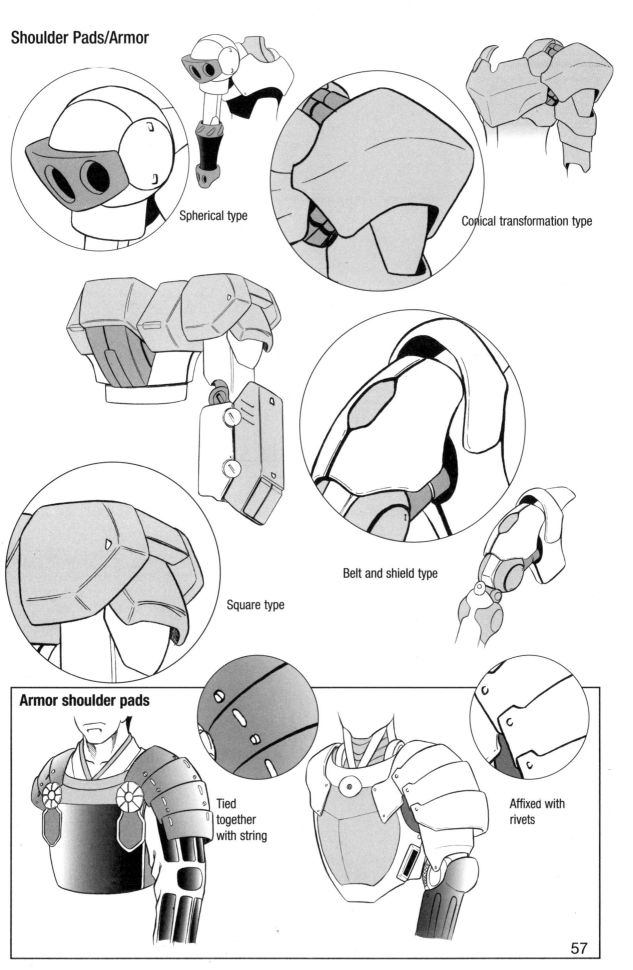

Spherical type

Conical transformation type

Square type

Belt and shield type

Armor shoulder pads

Tied together with string

Affixed with rivets

The direction of the sheers is changed by expansion and contraction of the shaft.

Opening and closing of the blades is controlled by upward and downward movement of pistons.

Cranes and claws

Opens when wire is pulled and closes when wire is let out.

Opens and closes with wire alone.

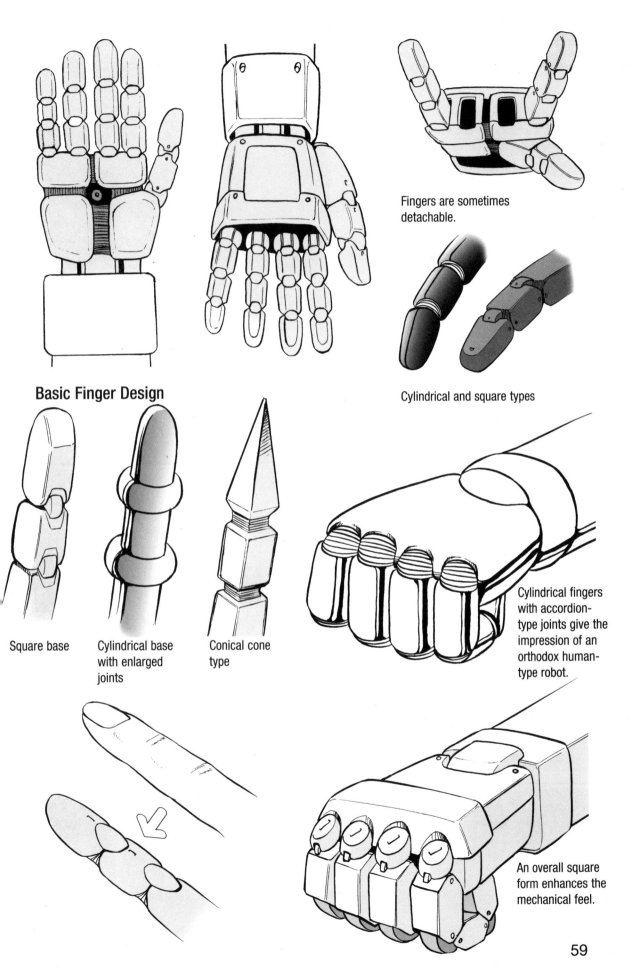

Fingers are sometimes detachable.

Cylindrical and square types

Basic Finger Design

Square base

Cylindrical base with enlarged joints

Conical cone type

Cylindrical fingers with accordion-type joints give the impression of an orthodox human-type robot.

An overall square form enhances the mechanical feel.

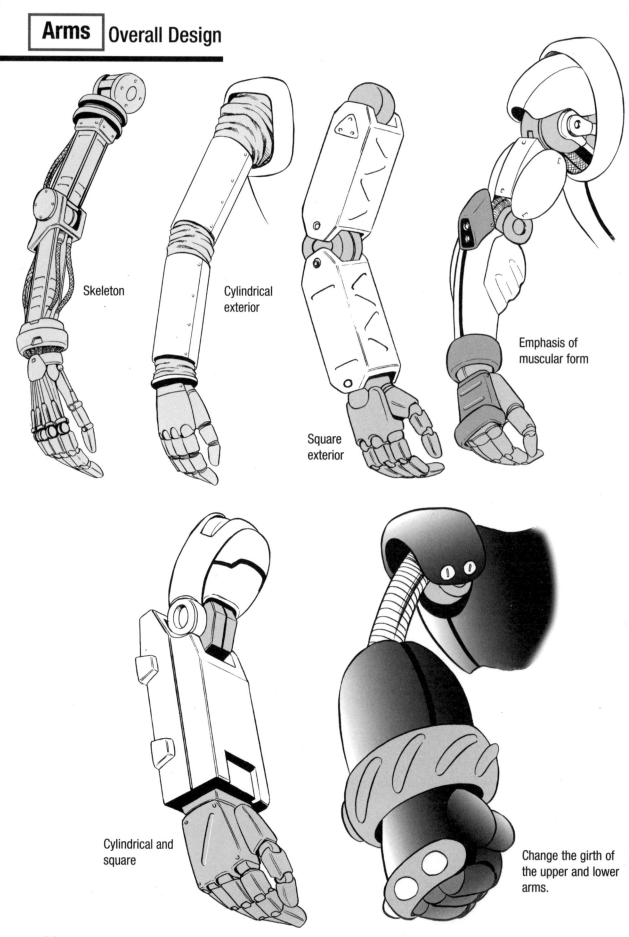

Skeleton

Cylindrical exterior

Square exterior

Emphasis of muscular form

Cylindrical and square

Change the girth of the upper and lower arms.

Optional Parts Variations

Shields/guards

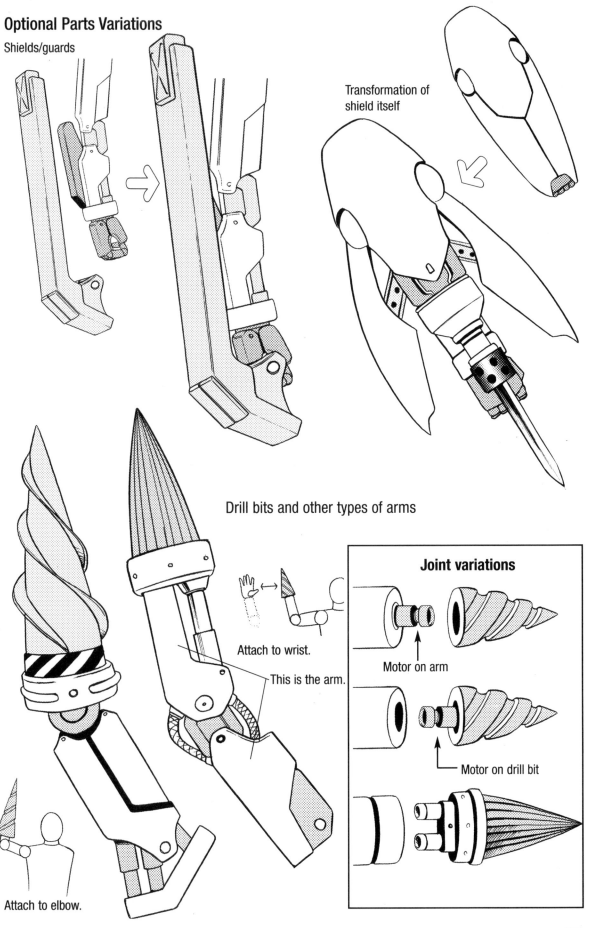

Transformation of shield itself

Drill bits and other types of arms

Attach to wrist.

This is the arm.

Attach to elbow.

Joint variations

Motor on arm

Motor on drill bit

Legs

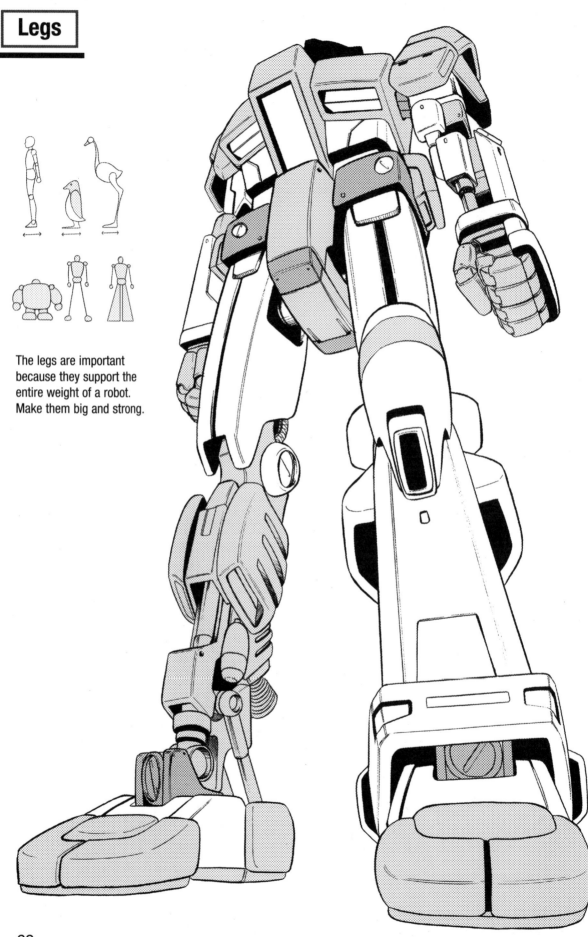

The legs are important because they support the entire weight of a robot. Make them big and strong.

Feet

Ankle joint

Suspension

The toes are
solidly built.

Short, Fat Legs Stocky legs create a sense of stability.

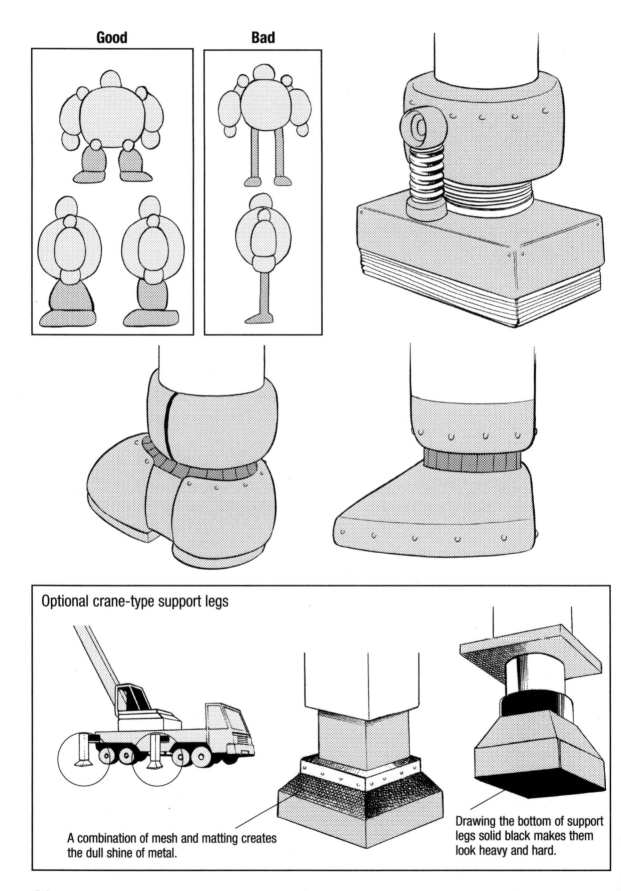

Good

Bad

Optional crane-type support legs

A combination of mesh and matting creates the dull shine of metal.

Drawing the bottom of support legs solid black makes them look heavy and hard.

Long, Slender Legs Draw the legs and feet large so that they are shaped like those in the illustrations below.

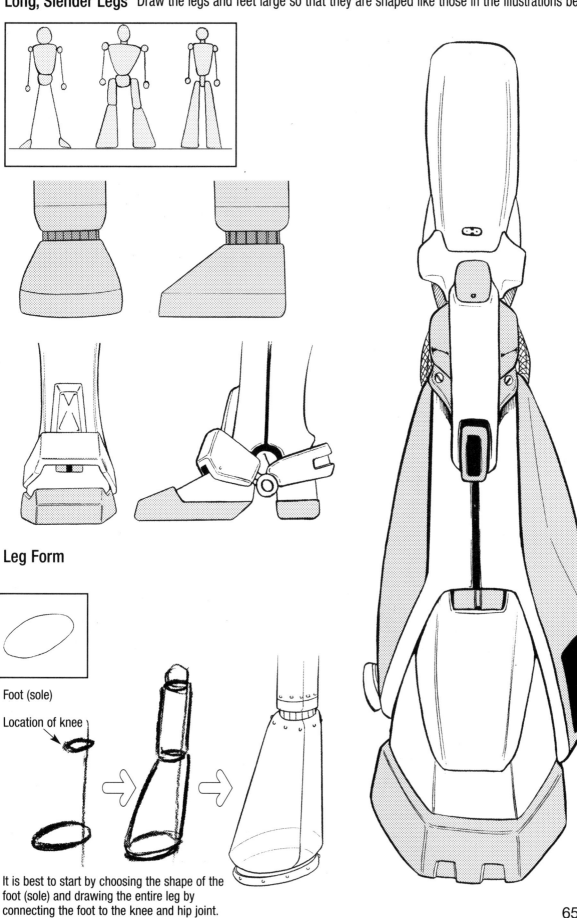

Leg Form

Foot (sole)

Location of knee

It is best to start by choosing the shape of the foot (sole) and drawing the entire leg by connecting the foot to the knee and hip joint.

Leg Design

Balance

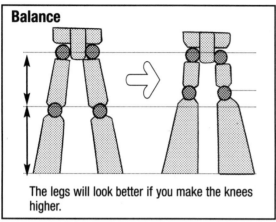

The legs will look better if you make the knees higher.

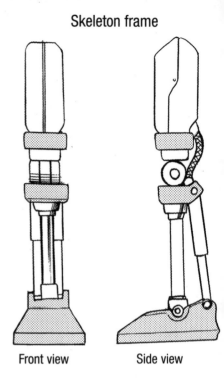

Front view Side view

Mechanical joint

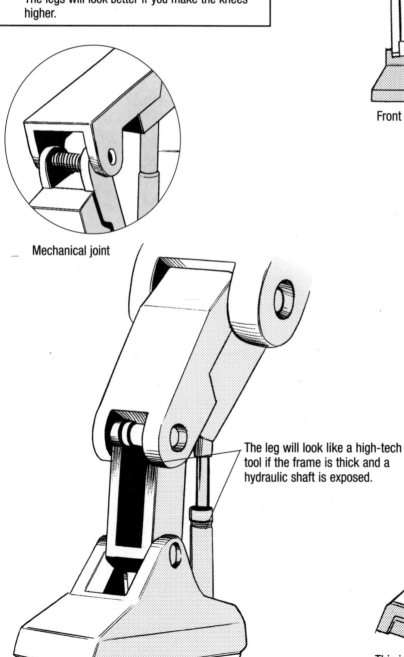

The leg will look like a high-tech tool if the frame is thick and a hydraulic shaft is exposed.

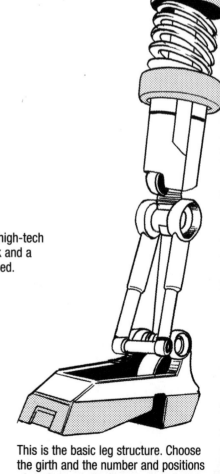

This is the basic leg structure. Choose the girth and the number and positions of shafts according to your tastes and how the robot will be used.

66

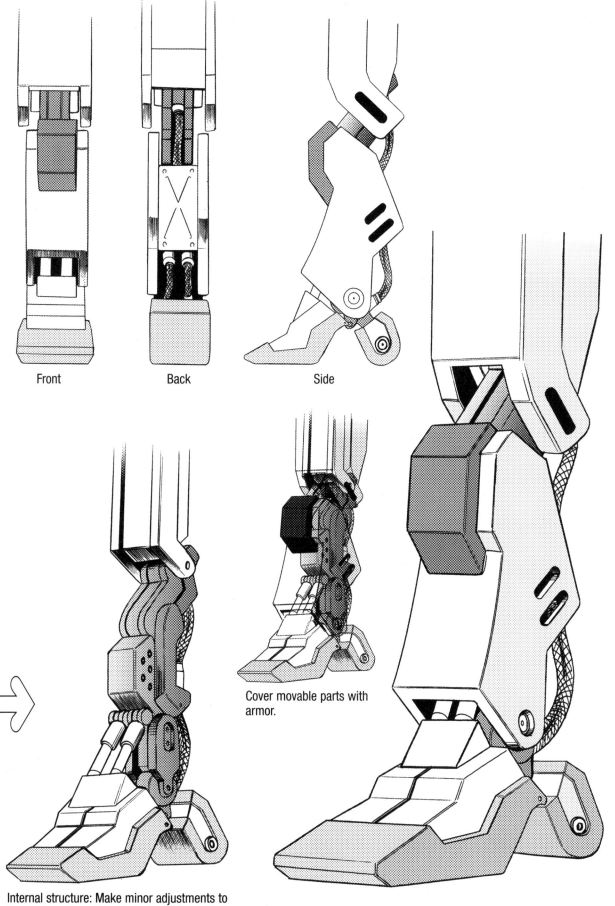

Front

Back

Side

Cover movable parts with armor.

Internal structure: Make minor adjustments to the angle and position of shafts. Add supplemental parts to create the effect of a mechanical interior.

Representation of Metallic Surfaces

Increasing the contrast between black and white (light) represents shining metal, while lowering the contrast creates the sense of metal or plastic with a dull shine.

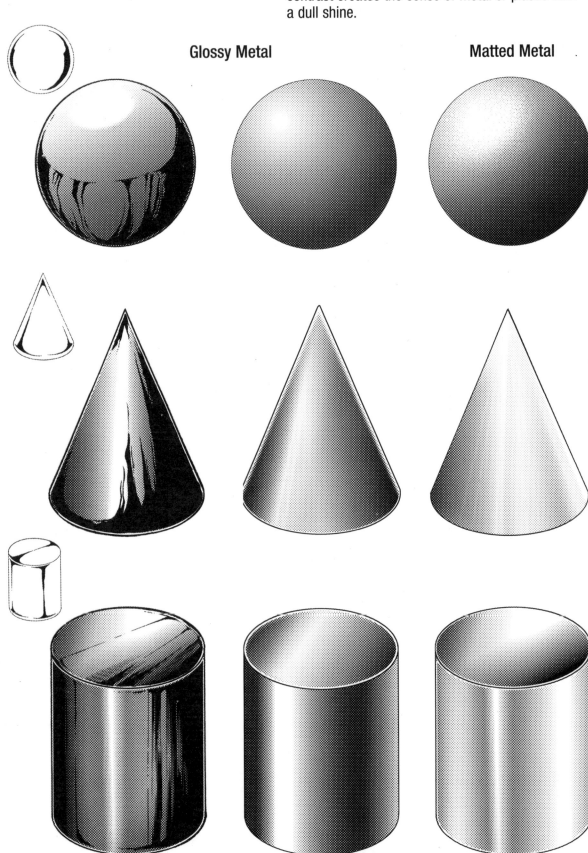

Glossy Metal

Matted Metal

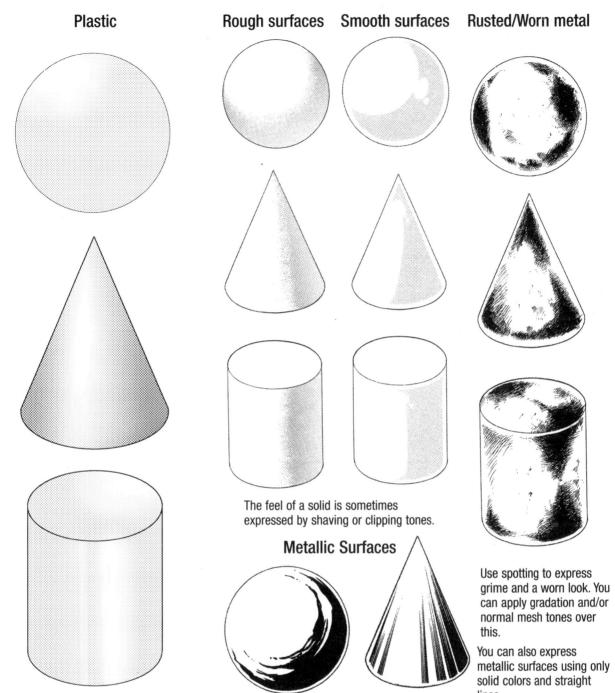

Plastic

Rough surfaces

Smooth surfaces

Rusted/Worn metal

The feel of a solid is sometimes expressed by shaving or clipping tones.

Metallic Surfaces

Use spotting to express grime and a worn look. You can apply gradation and/or normal mesh tones over this.

You can also express metallic surfaces using only solid colors and straight lines.

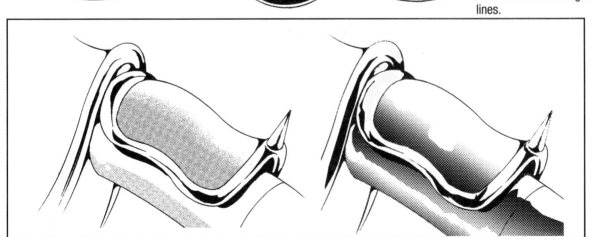

Using Tones to Create Curve Effects

Express curve lines by using a combination of spheres, cones and cylinders.

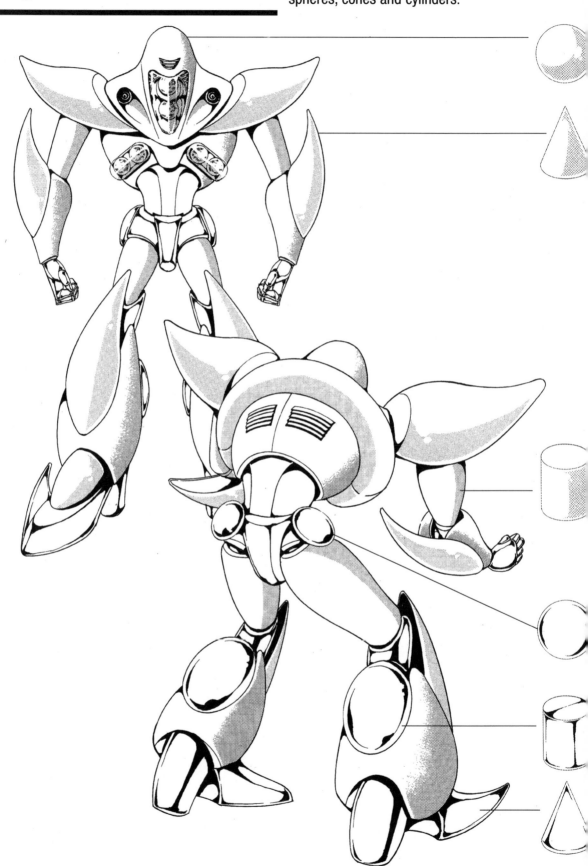

Step 1

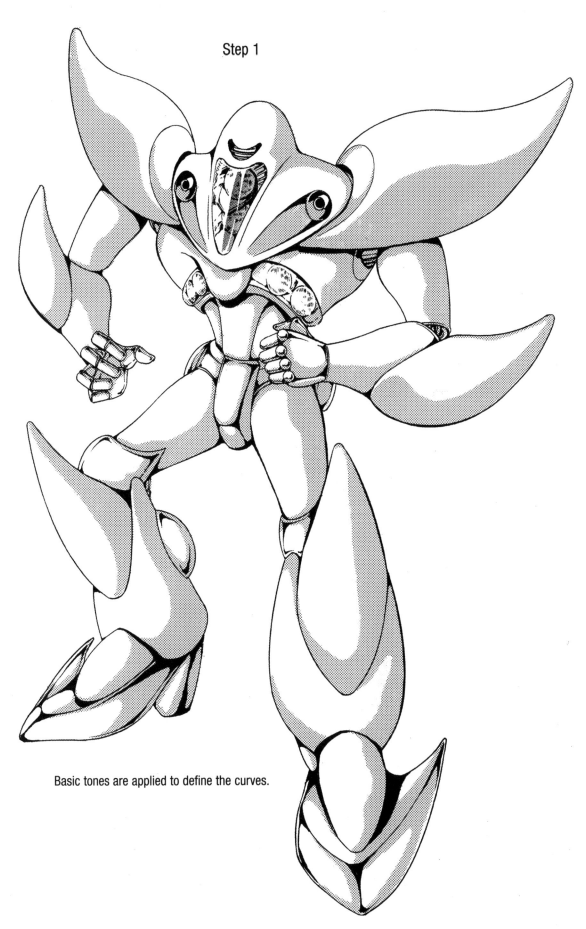

Basic tones are applied to define the curves.

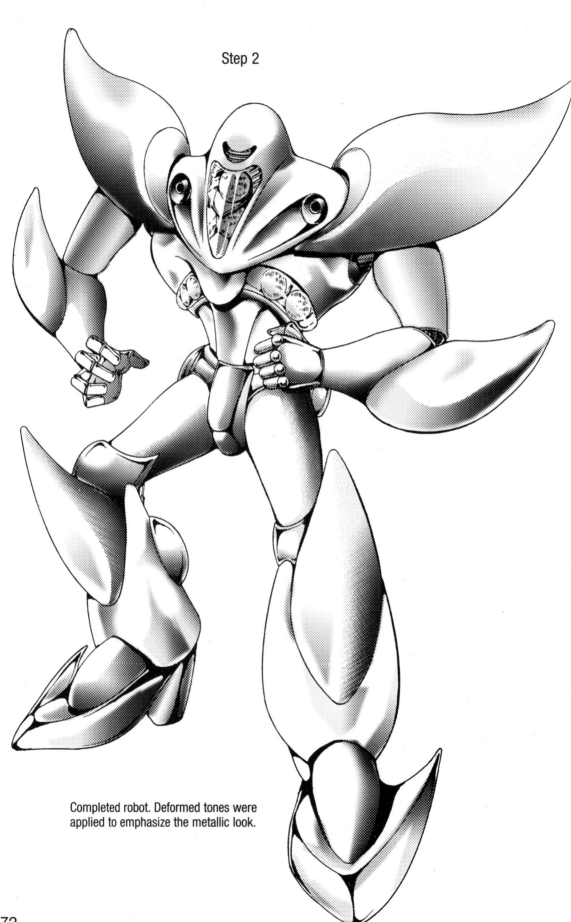

Completed robot. Deformed tones were
applied to emphasize the metallic look.

Section 2
Combat Robots

Design Based on Medieval Armor

A classic suit of armor can be rendered into a modern-day mecha by simplifying and deforming the parts without significantly altering the overall form.

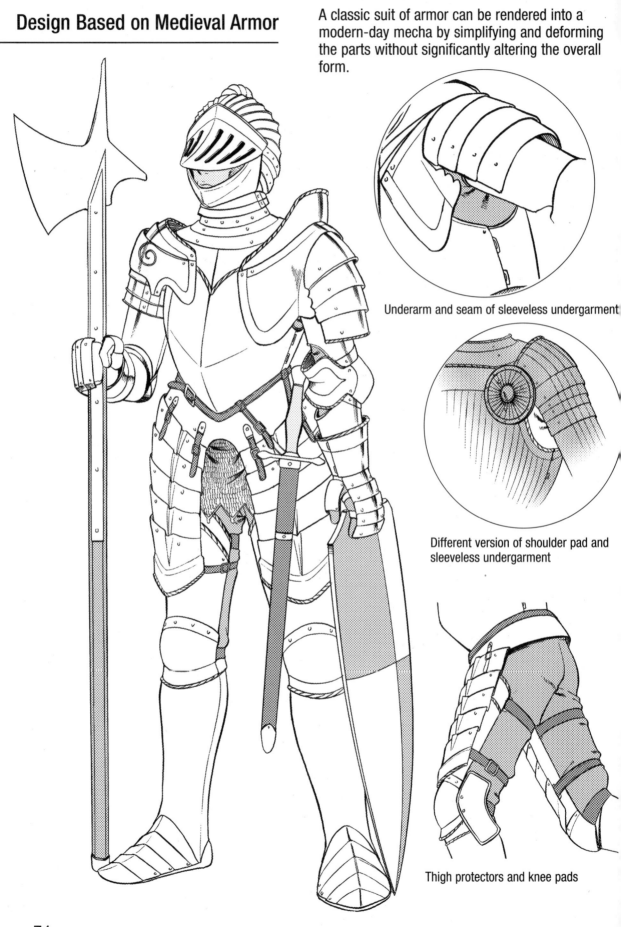

Underarm and seam of sleeveless undergarment

Different version of shoulder pad and sleeveless undergarment

Thigh protectors and knee pads

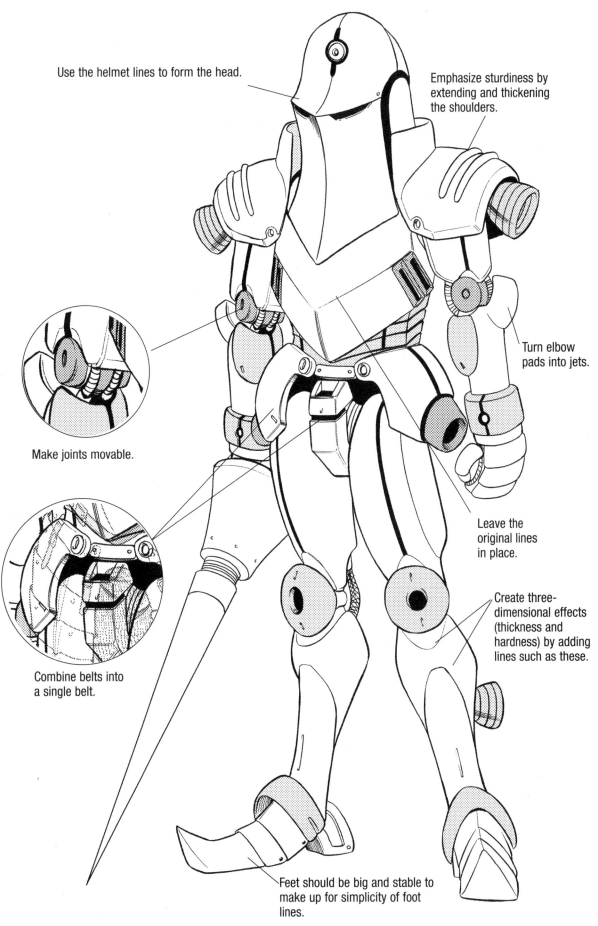

Use the helmet lines to form the head.

Emphasize sturdiness by extending and thickening the shoulders.

Turn elbow pads into jets.

Make joints movable.

Leave the original lines in place.

Create three-dimensional effects (thickness and hardness) by adding lines such as these.

Combine belts into a single belt.

Feet should be big and stable to make up for simplicity of foot lines.

Arrangement of Swords, Axes and Spears for Use with Robots

Classic weapons should retain their original overall form but feature minor modifications to make them look futuristic.

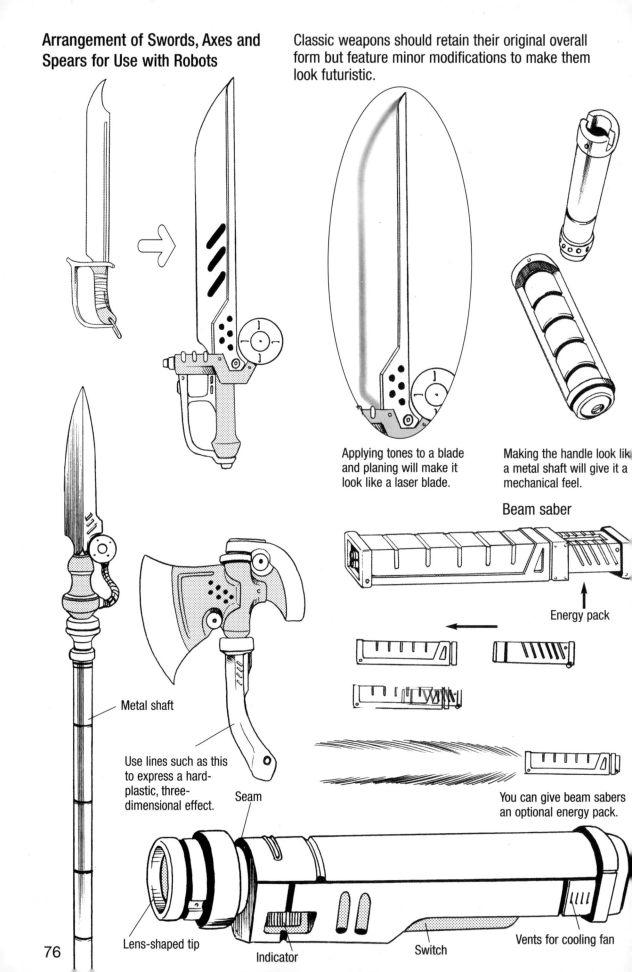

Applying tones to a blade and planing will make it look like a laser blade.

Making the handle look lik a metal shaft will give it a mechanical feel.

Beam saber

Energy pack

You can give beam sabers an optional energy pack.

Metal shaft

Use lines such as this to express a hard-plastic, three-dimensional effect.

Seam

Lens-shaped tip

Indicator

Switch

Vents for cooling fan

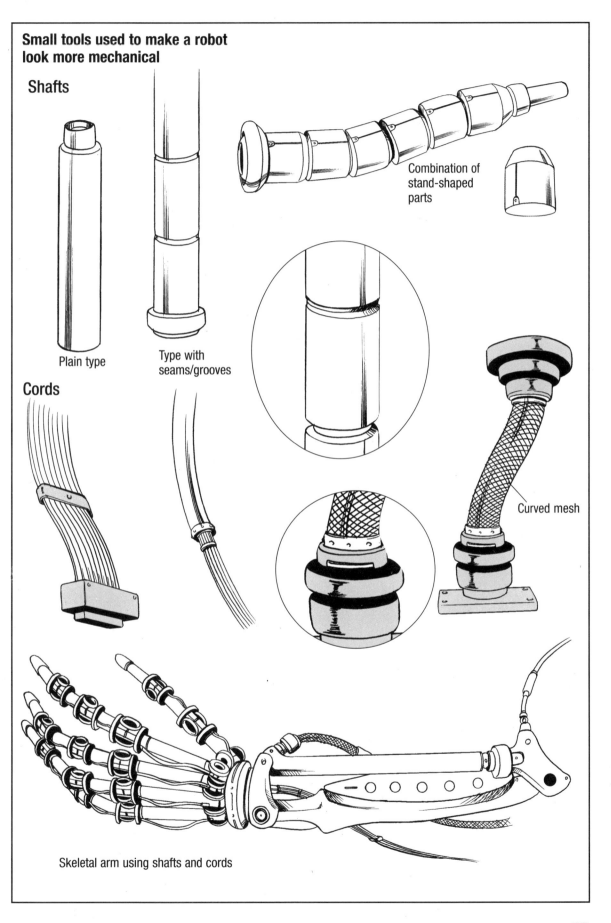

Small tools used to make a robot look more mechanical

Shafts

Combination of stand-shaped parts

Plain type

Type with seams/grooves

Cords

Curved mesh

Skeletal arm using shafts and cords

Robots Based on Combat Uniforms

Special-forces style. Refer to space suits and diving suits.

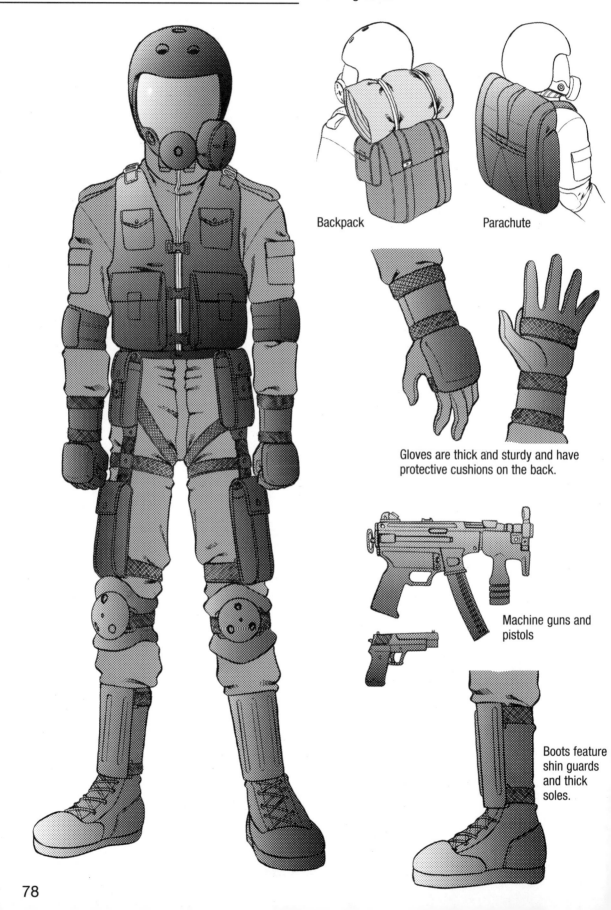

Backpack

Parachute

Gloves are thick and sturdy and have protective cushions on the back.

Machine guns and pistols

Boots feature shin guards and thick soles.

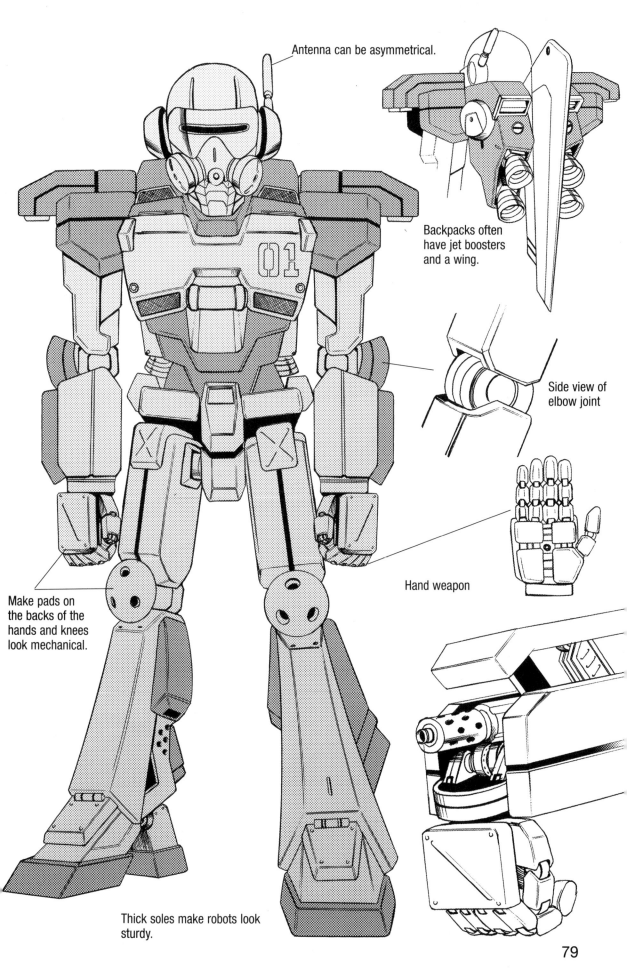

Antenna can be asymmetrical.

Backpacks often have jet boosters and a wing.

Side view of elbow joint

Hand weapon

Make pads on the backs of the hands and knees look mechanical.

Thick soles make robots look sturdy.

79

Design of Head

You can use a pilot's helmet to help you design a robot's face.

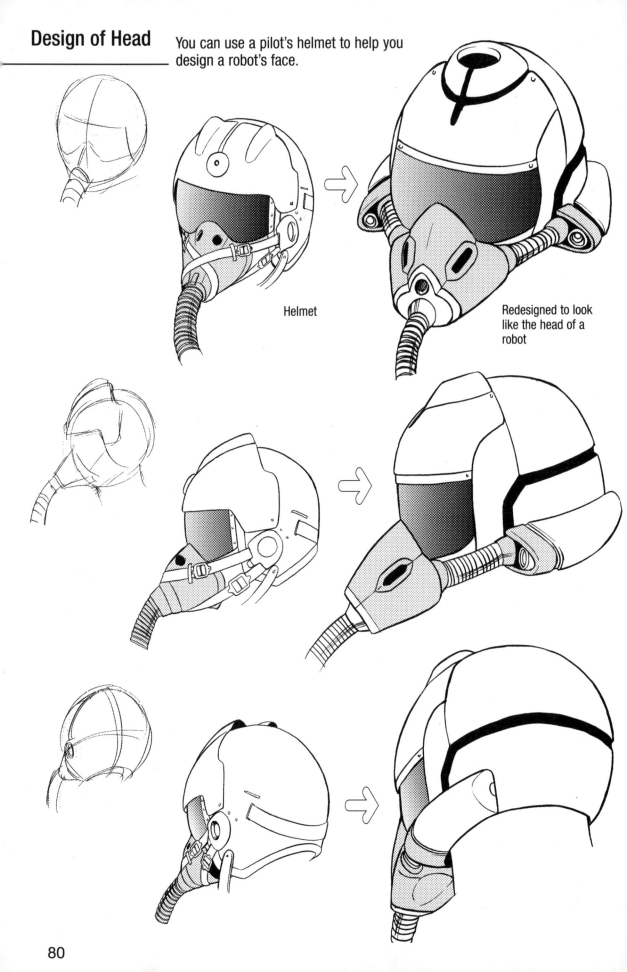

Helmet

Redesigned to look like the head of a robot

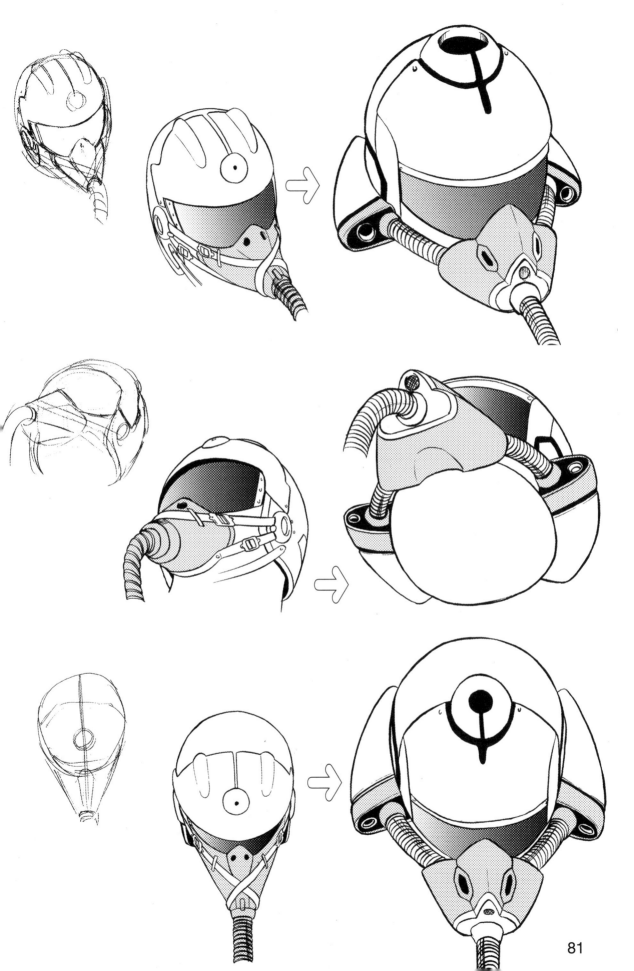

Weapons Base stance and grip on actual pose.

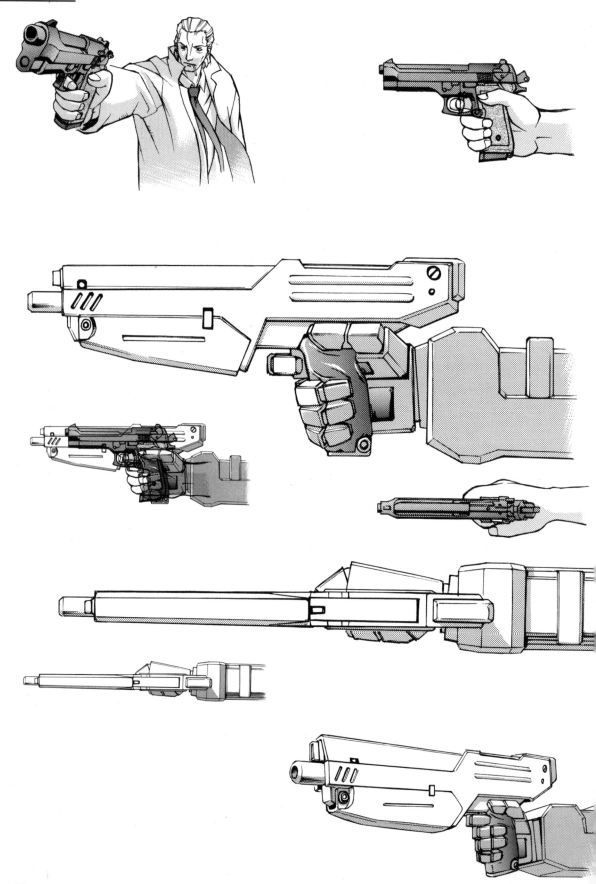

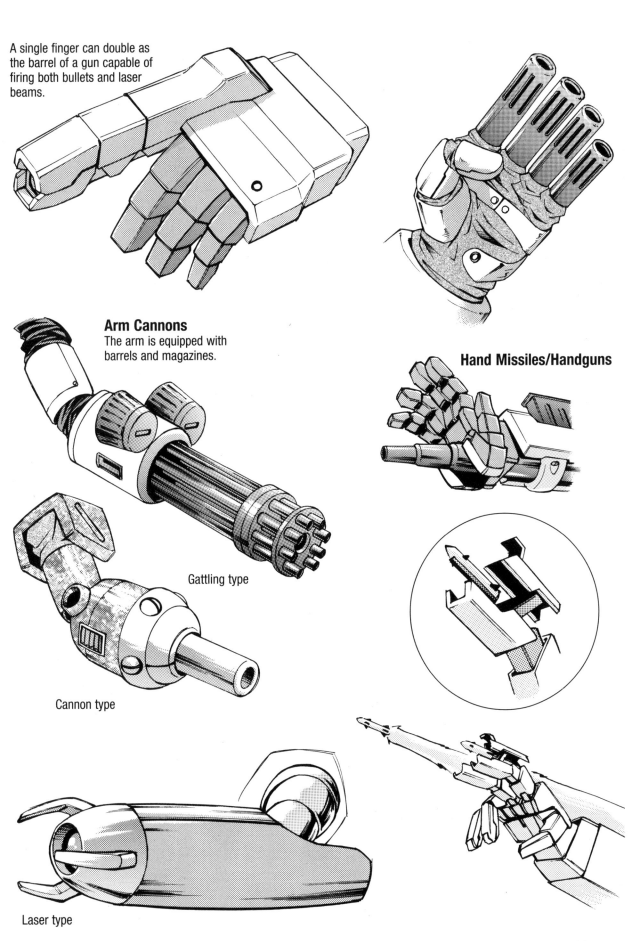

A single finger can double as the barrel of a gun capable of firing both bullets and laser beams.

Arm Cannons
The arm is equipped with barrels and magazines.

Hand Missiles/Handguns

Gattling type

Cannon type

Laser type

Magazine Arrangements

Apply magazines and loading systems to robot arm weapons.

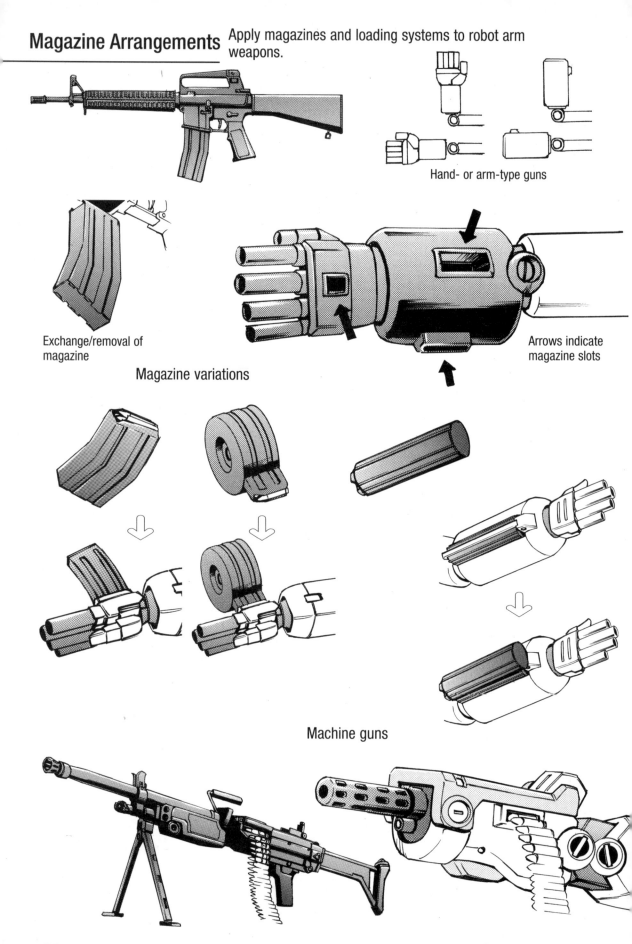

Hand- or arm-type guns

Exchange/removal of magazine

Magazine variations

Arrows indicate magazine slots

Machine guns

Exchange and transformation of options

You can get a variety of shapes by exchanging and combining barrels and stocks.

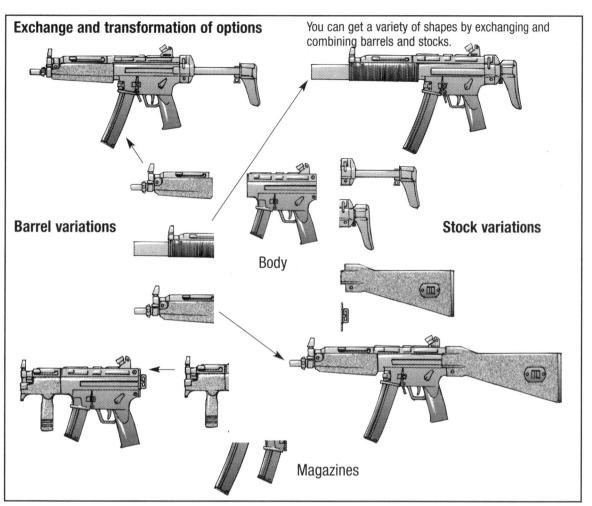

Barrel variations

Body

Stock variations

Magazines

Energy Guns

Various Futuristic Guns

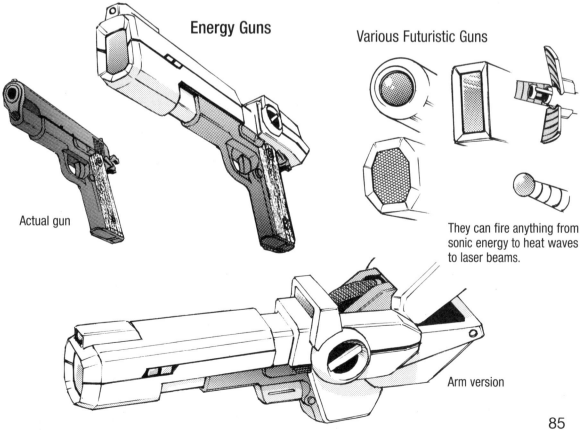

Actual gun

They can fire anything from sonic energy to heat waves to laser beams.

Arm version

Barrels and Muzzles

Use a variety of gun types, including sidearms, rifles and automatics.

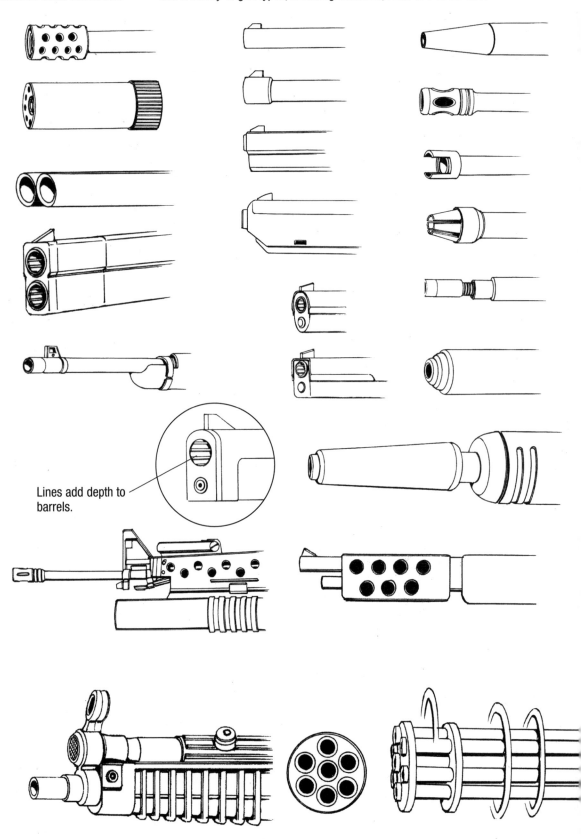

Lines add depth to barrels.

Bazooka

Tank turret

Simple type

Muzzle

Tip of self-propelled
anti-aircraft gun

Missiles

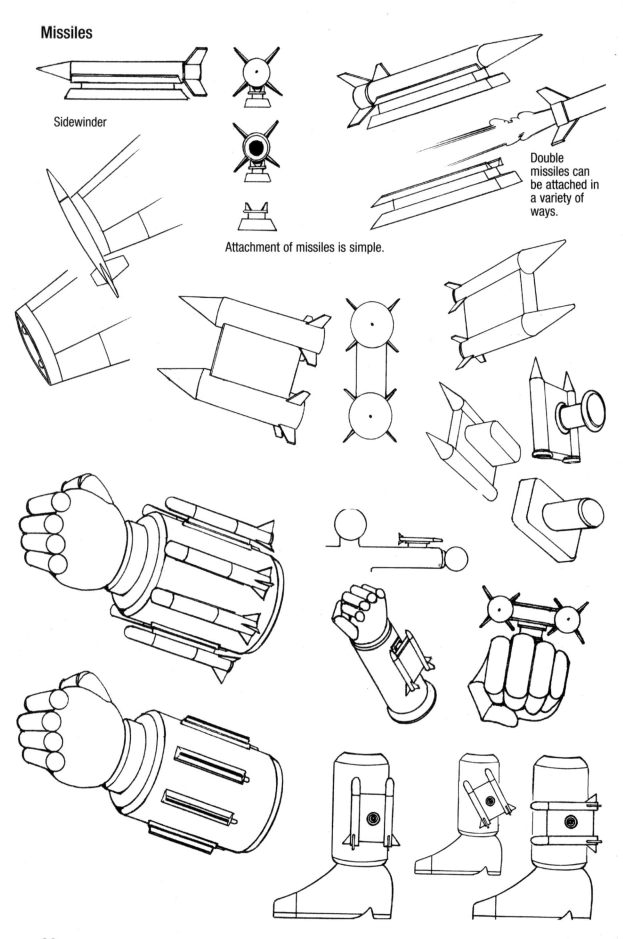

Sidewinder

Attachment of missiles is simple.

Double missiles can be attached in a variety of ways.

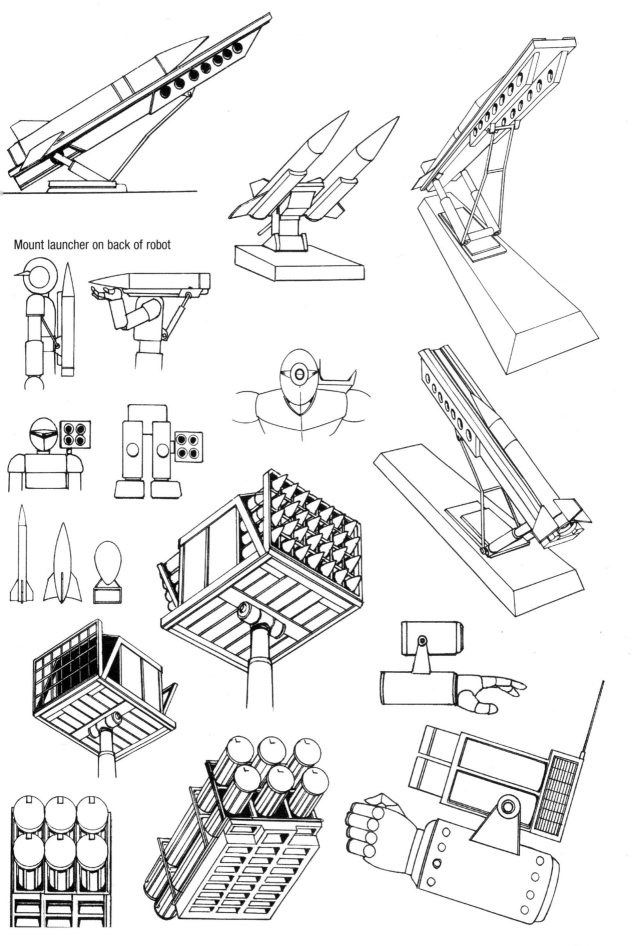

Mount launcher on back of robot

Transportation Units

Common items such as skates can be transformed into high-tech conveyances.

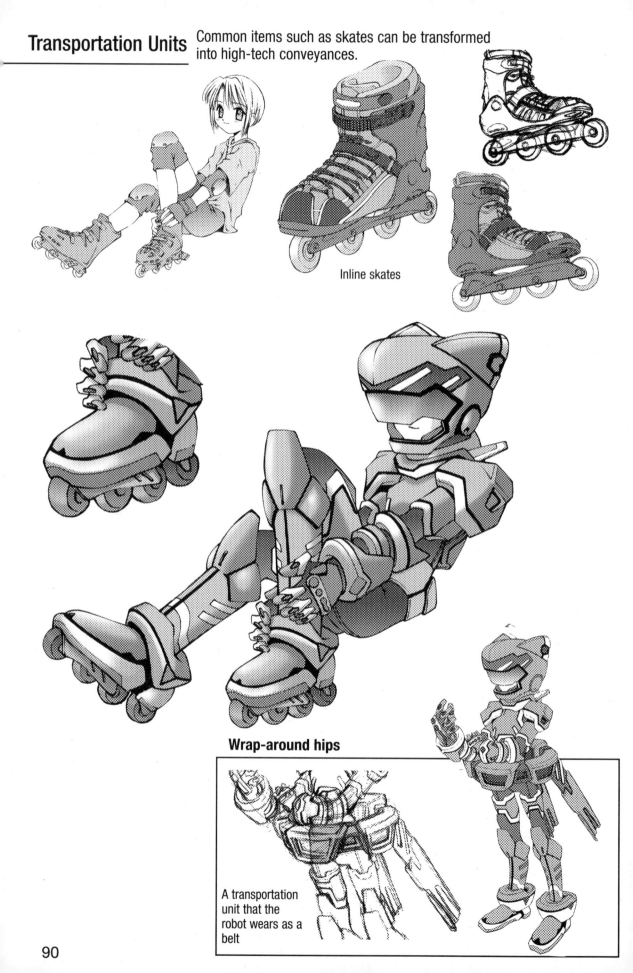

Inline skates

Wrap-around hips

A transportation unit that the robot wears as a belt

Shoes with tires have the same form as inline skates.

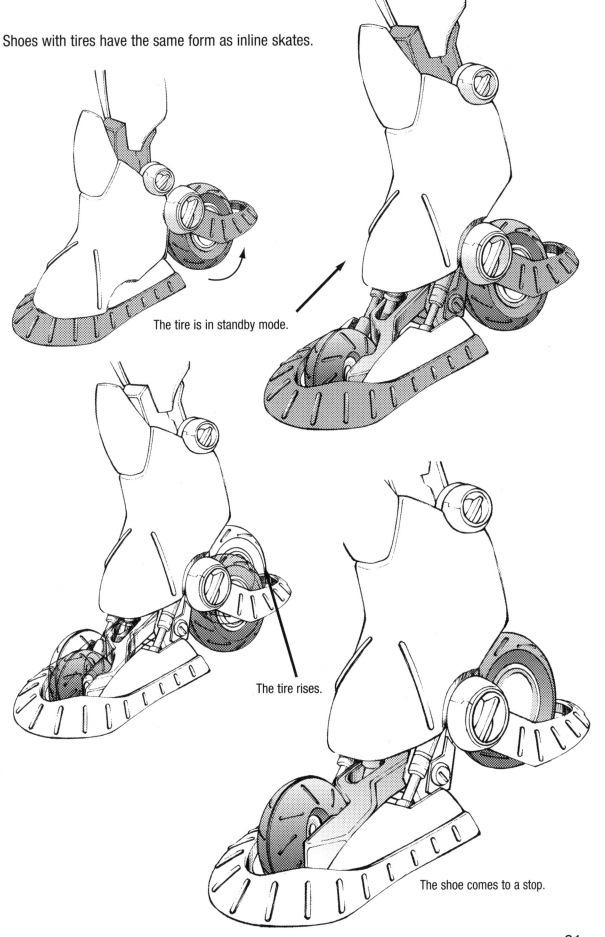

The tire is in standby mode.

The tire rises.

The shoe comes to a stop.

Using Ski Boots and Bindings as Catapults

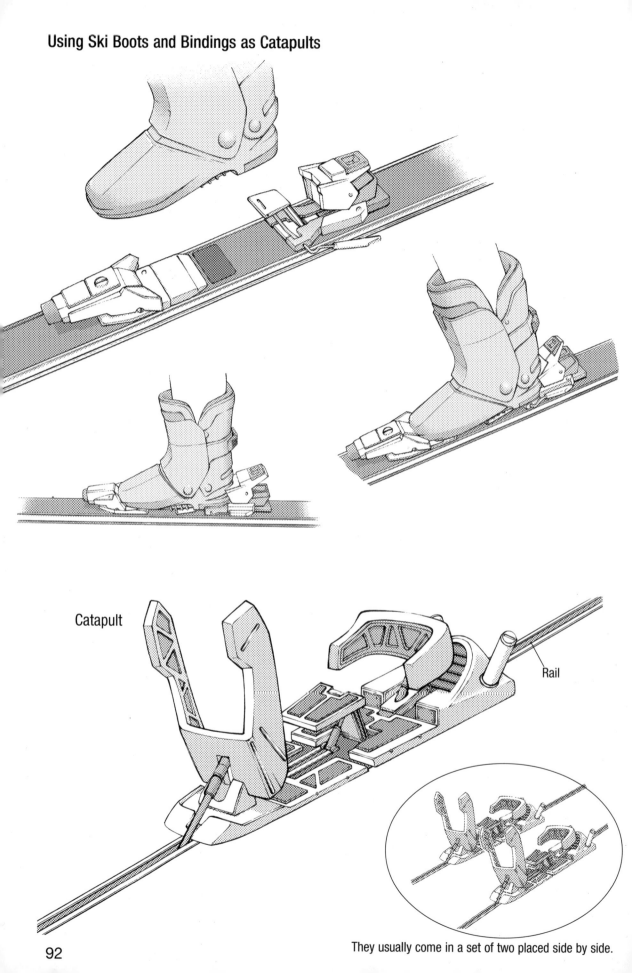

Catapult

Rail

They usually come in a set of two placed side by side.

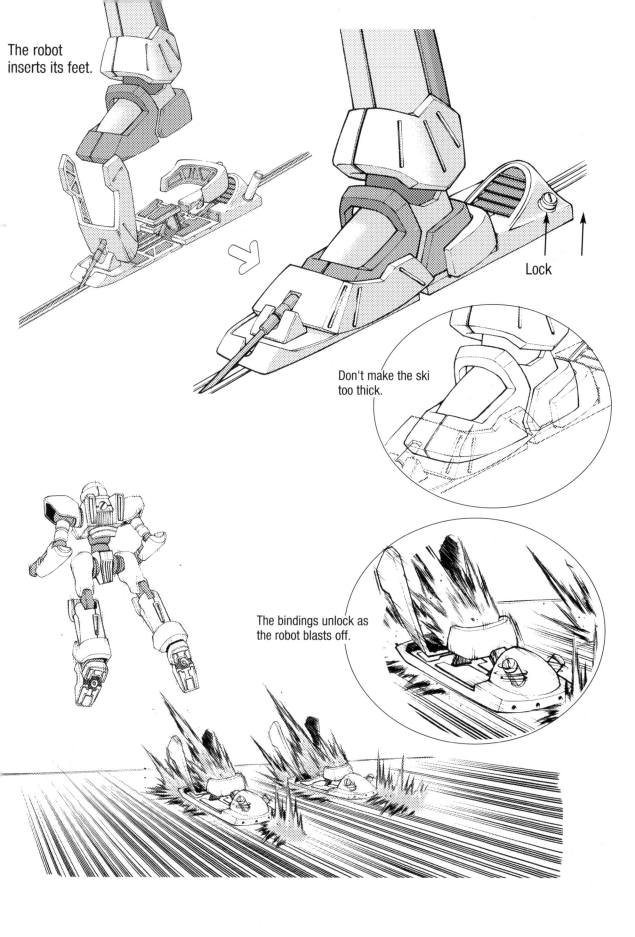

The robot
inserts its feet.

Lock

Don't make the ski
too thick.

The bindings unlock as
the robot blasts off.

Changing Lower Body Parts
Transportation devices can be attached in place of the lower body.

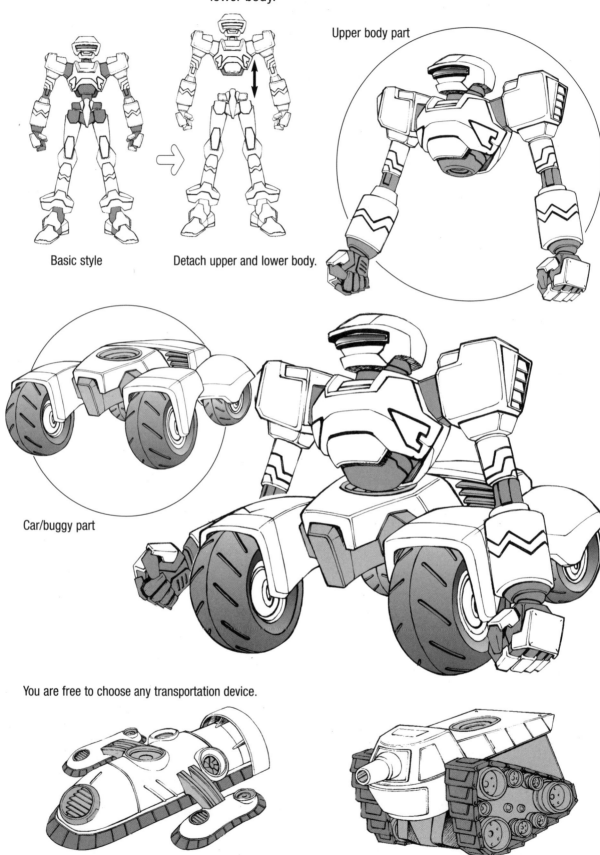

Basic style

Detach upper and lower body.

Upper body part

Car/buggy part

You are free to choose any transportation device.

Marine type

Tank type

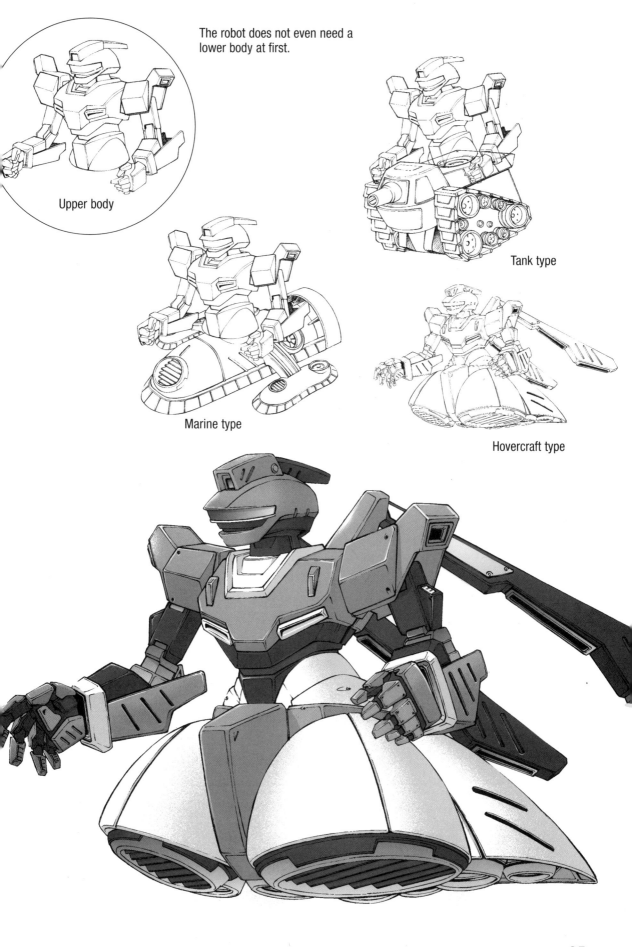

The robot does not even need a lower body at first.

Upper body

Tank type

Marine type

Hovercraft type

Flying Parts and Wings

There are two types of wings: Those that are vertical to the body and those that are horizontal to the body.

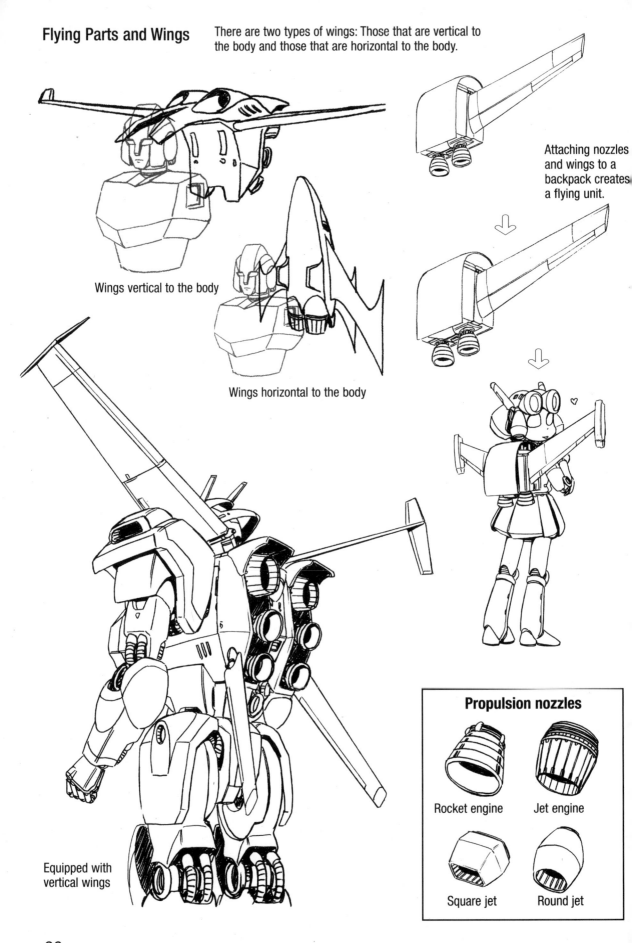

Wings vertical to the body

Wings horizontal to the body

Attaching nozzles and wings to a backpack creates a flying unit.

Equipped with vertical wings

Propulsion nozzles

Rocket engine

Jet engine

Square jet

Round jet

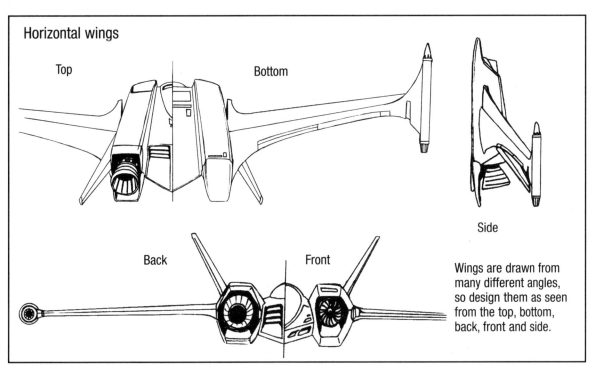

Horizontal wings

Top

Bottom

Side

Back

Front

Wings are drawn from many different angles, so design them as seen from the top, bottom, back, front and side.

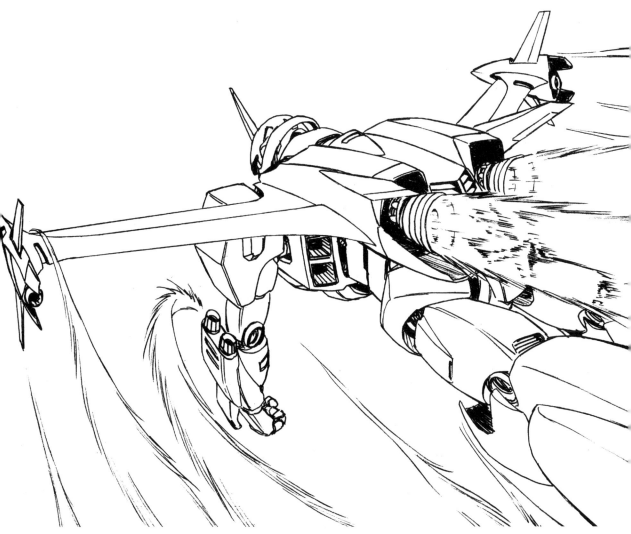

Transformers

Jet fighters

Create a robot by combining parts from jet fighters, cars and other objects. Make use of the original objects' characteristics.

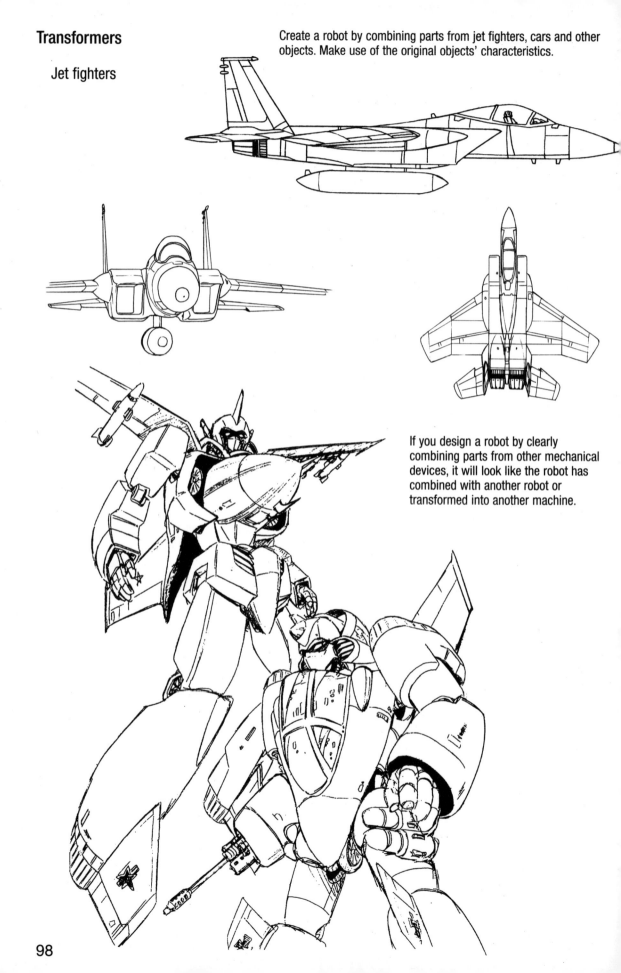

If you design a robot by clearly combining parts from other mechanical devices, it will look like the robot has combined with another robot or transformed into another machine.

Cars

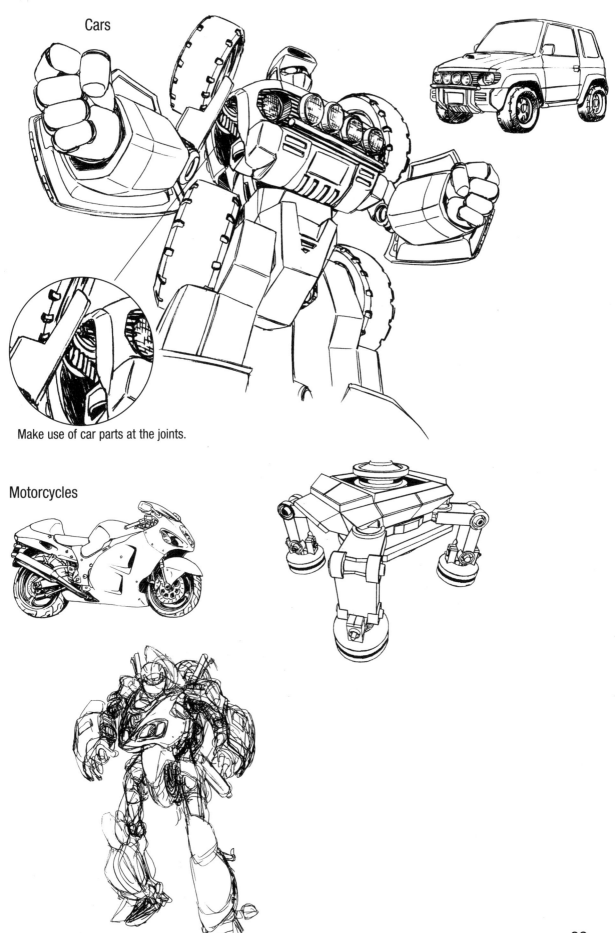

Make use of car parts at the joints.

Motorcycles

Color Expression and Special Effects

Color is expressed in terms of differences in gray tones (dark or light). When you make a black-and white copy of a color picture, the colors will be gray. Use that as a reference.

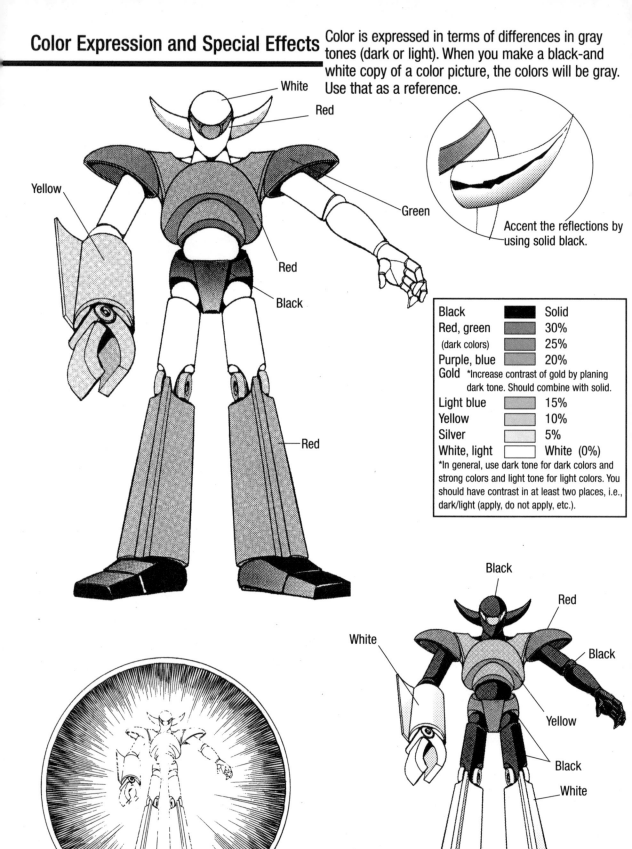

White

Red

Yellow

Green

Red

Black

Red

Accent the reflections by using solid black.

Black	■	Solid
Red, green		30%
(dark colors)		25%
Purple, blue		20%
Gold	*Increase contrast of gold by planing	
	dark tone. Should combine with solid.	
Light blue		15%
Yellow		10%
Silver		5%
White, light	☐	White (0%)

*In general, use dark tone for dark colors and strong colors and light tone for light colors. You should have contrast in at least two places, i.e., dark/light (apply, do not apply, etc.).

Black

Red

White

Black

Yellow

Black

White

Red

In this illustration, the robot's entire body radiates light.

Flames and Backfire

Red flames

Blue and white flames

Air/jet blast

Flames and hot air

Red accompanied by explosion

Fast-streaming red

Ink splatters are an effective way
to depict an explosion.

Presentation of eyes

Dull shine

Normal eye

Red

Shining red

Red or blue light beam

White light beam

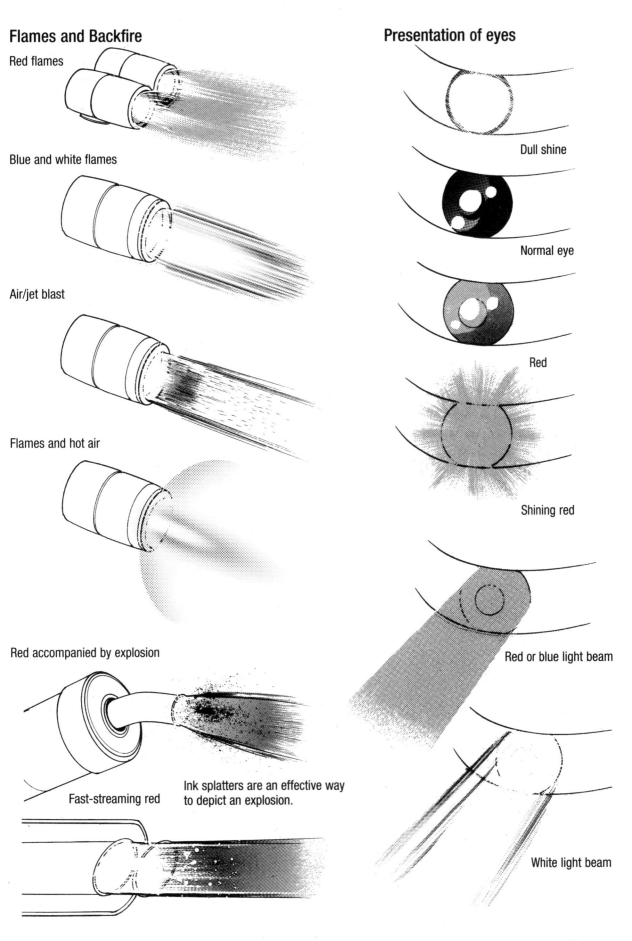

Explosions and Smoke

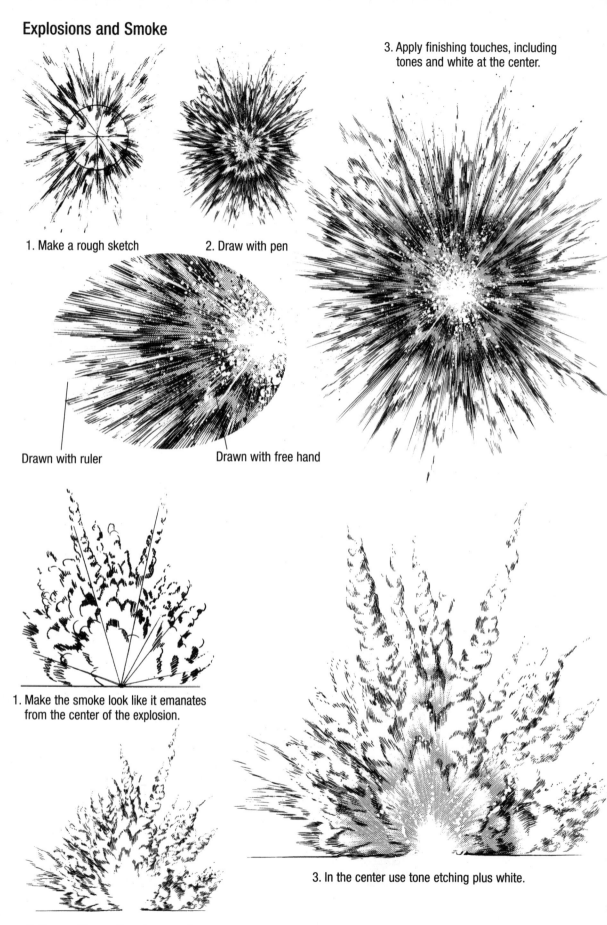

1. Make a rough sketch

2. Draw with pen

3. Apply finishing touches, including tones and white at the center.

Drawn with ruler

Drawn with free hand

1. Make the smoke look like it emanates from the center of the explosion.

2. Draw with pen. Do not use a ruler.

3. In the center use tone etching plus white.

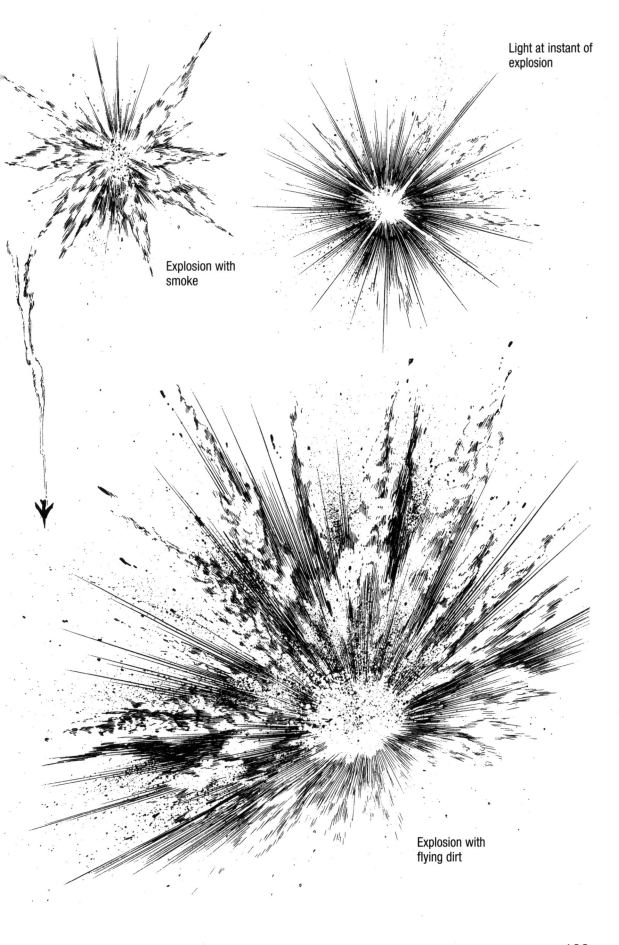

Explosion with
smoke

Light at instant of
explosion

Explosion with
flying dirt

103

Designing Original Robots

Think about the body parts as you draw. You can create an original robot if you design each individual part and combine them using the three basic views.

Head

Auxiliary head part...

...combined with shoulder armor

Shoulder armor

Left arm

View of head and shoulders from above

Chest

Core/movable unit

Upper body

Right arm

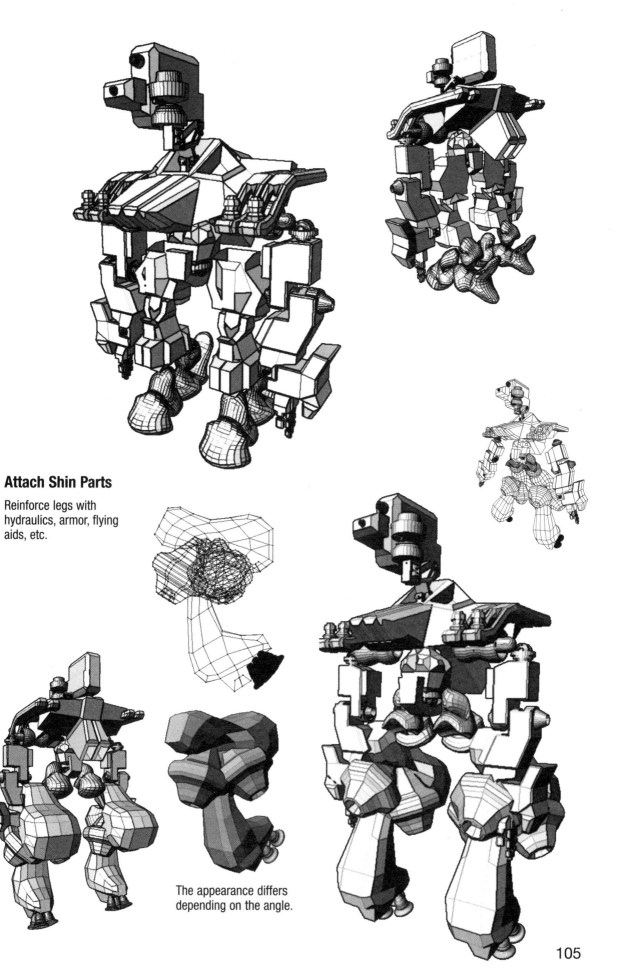

Attach Shin Parts

Reinforce legs with hydraulics, armor, flying aids, etc.

The appearance differs depending on the angle.

Flying Robots Swap flying devices with the head to emphasize the primary function of the robot.

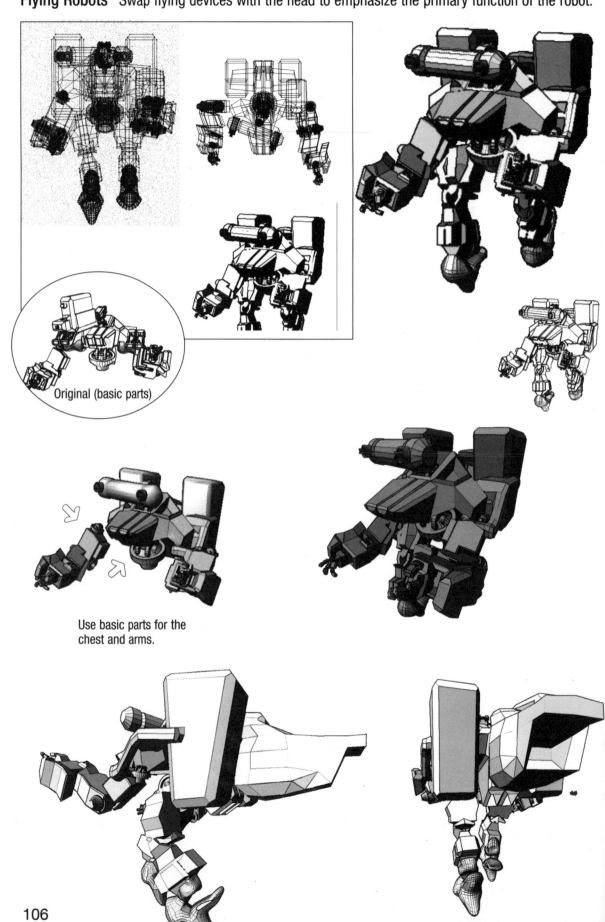

Original (basic parts)

Use basic parts for the chest and arms.

Attach wings

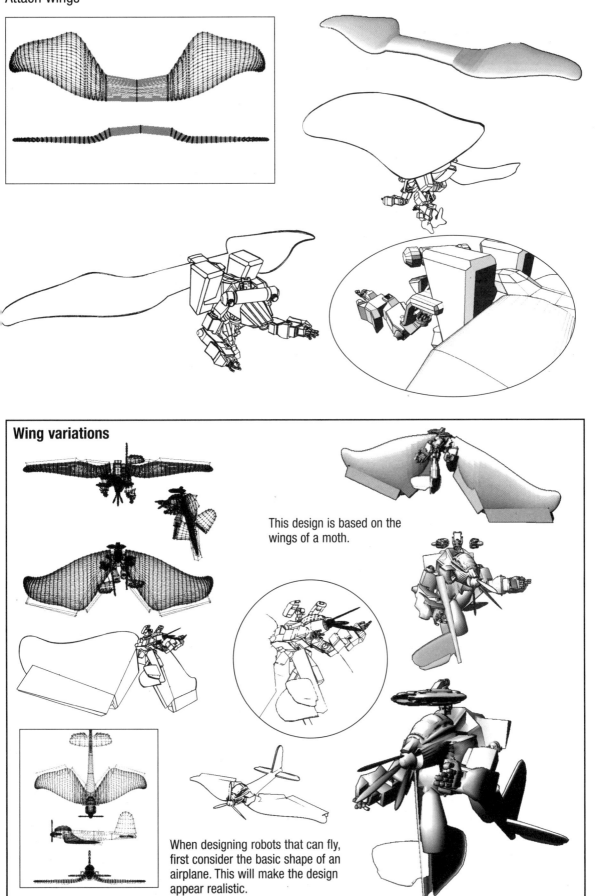

Wing variations

This design is based on the wings of a moth.

When designing robots that can fly, first consider the basic shape of an airplane. This will make the design appear realistic.

Add Joints to Connect Machines

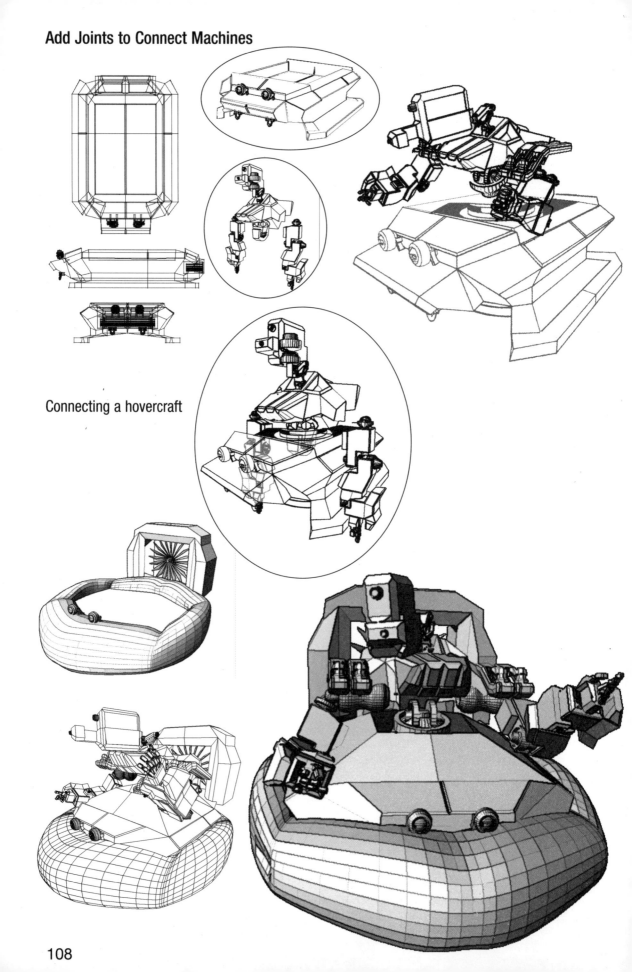

Connecting a hovercraft

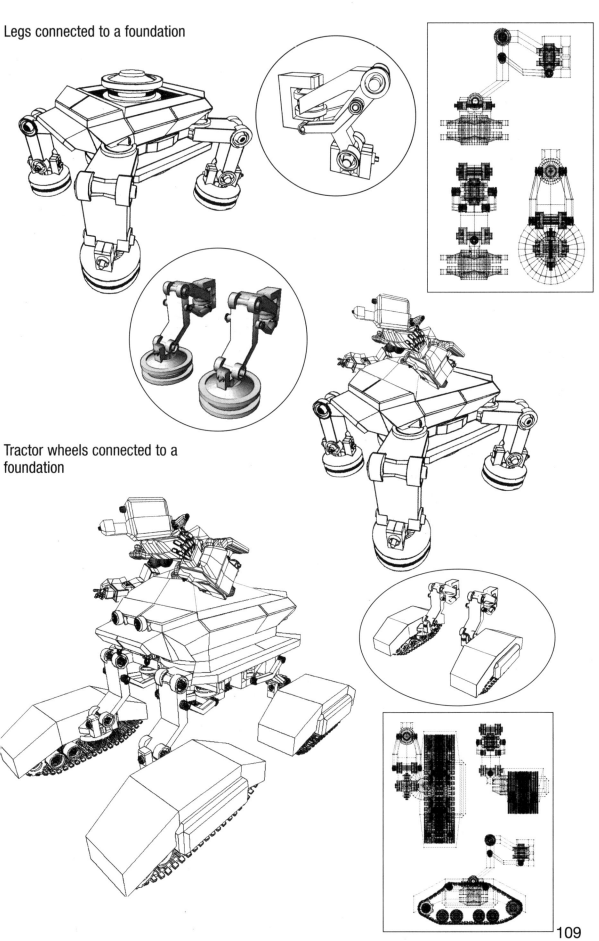

Legs connected to a foundation

Tractor wheels connected to a
foundation

109

Robots with Tires

Leave the original head and arms. The robot will look like a completely different machine if you put armor on the body and make the lower body a tire mechanism.

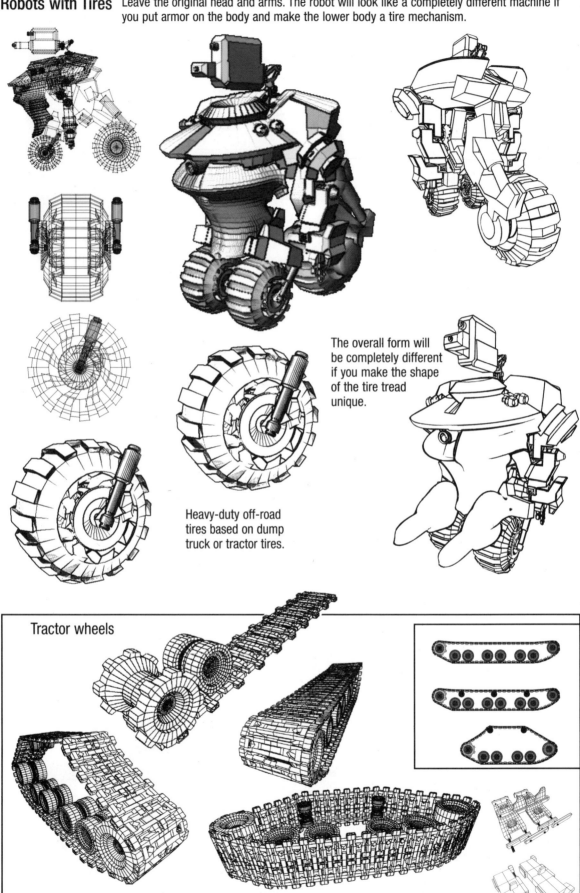

The overall form will be completely different if you make the shape of the tire tread unique.

Heavy-duty off-road tires based on dump truck or tractor tires.

Tractor wheels

Section 3
Female Robots

Designing Body Lines
There are two ways to approach deformation of physical characteristics.

Nude base

Removing roundness
Straight line type. Draw as if the entire body was covered with a combination of iron plates. This creates the look of a classic robot.

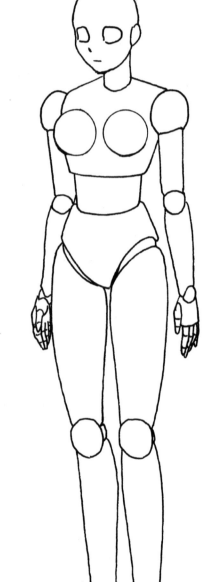

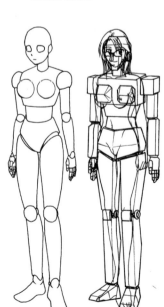

To improve the balance, draw the bust a little higher than it would be in real life.

Curved approach
Use mainly curved lines to accentuate the curved surfaces and roundness of the body. Look at mannequins or figurines for inspiration.

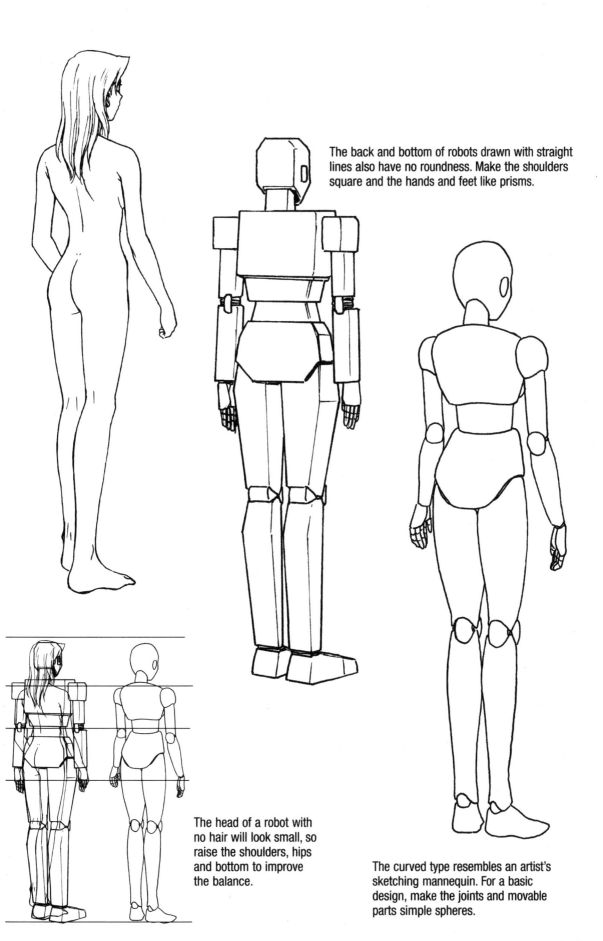

The back and bottom of robots drawn with straight lines also have no roundness. Make the shoulders square and the hands and feet like prisms.

The head of a robot with no hair will look small, so raise the shoulders, hips and bottom to improve the balance.

The curved type resembles an artist's sketching mannequin. For a basic design, make the joints and movable parts simple spheres.

Designing Breasts

Human

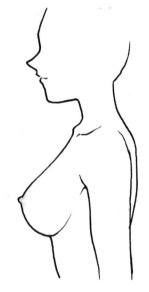 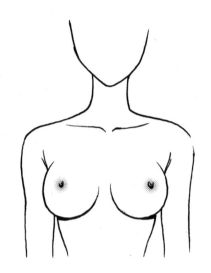 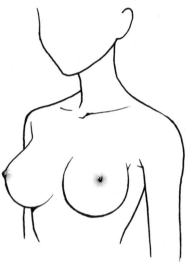

Cubic/armored type

Mannequin/android type

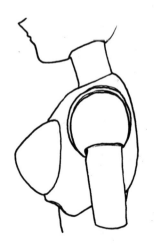 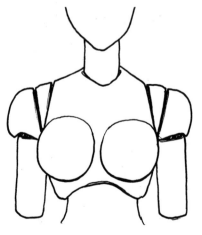 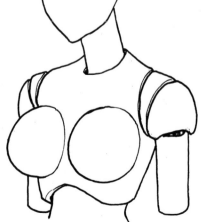

Bust Variations

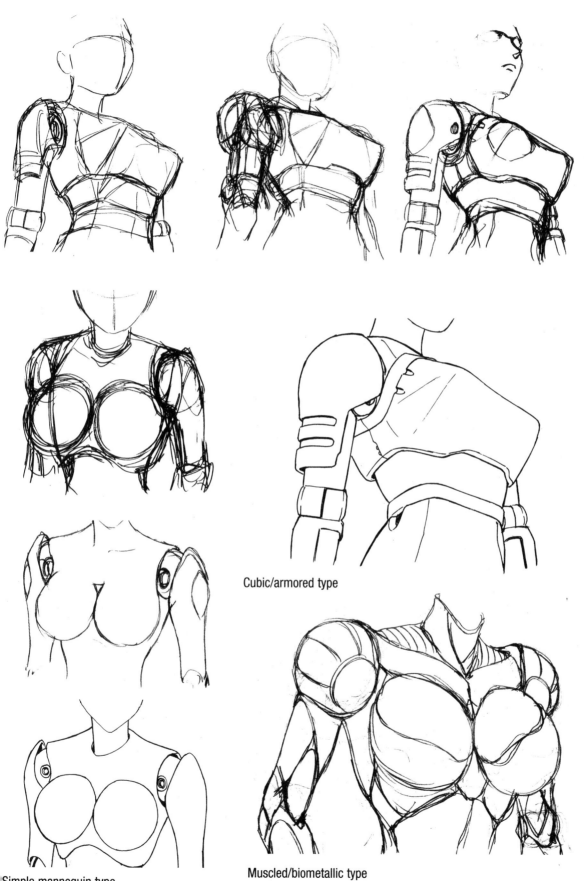

Cubic/armored type

Simple mannequin type

Muscled/biometallic type

Designing Bottoms

Human

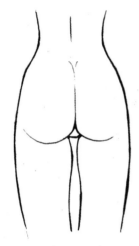 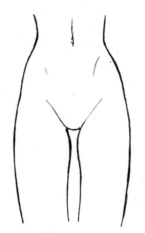

Cubic/armored type

 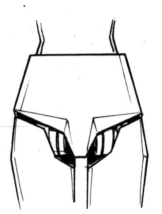 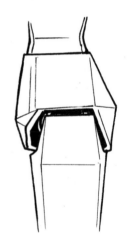

Mannequin/android type

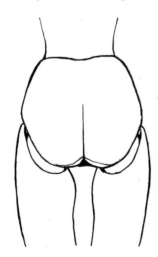 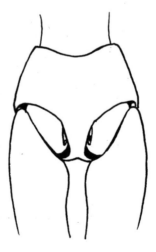

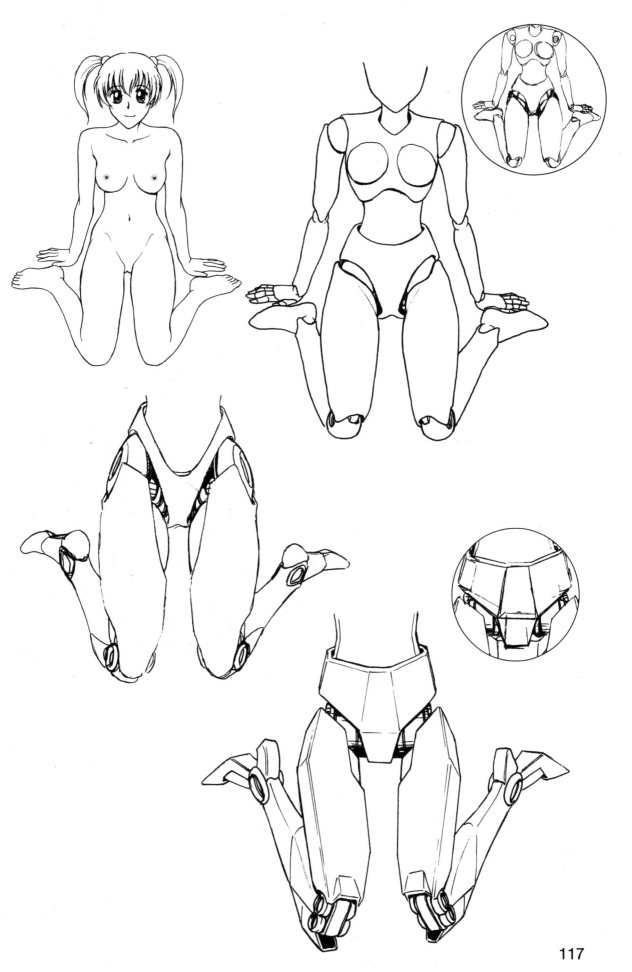

117

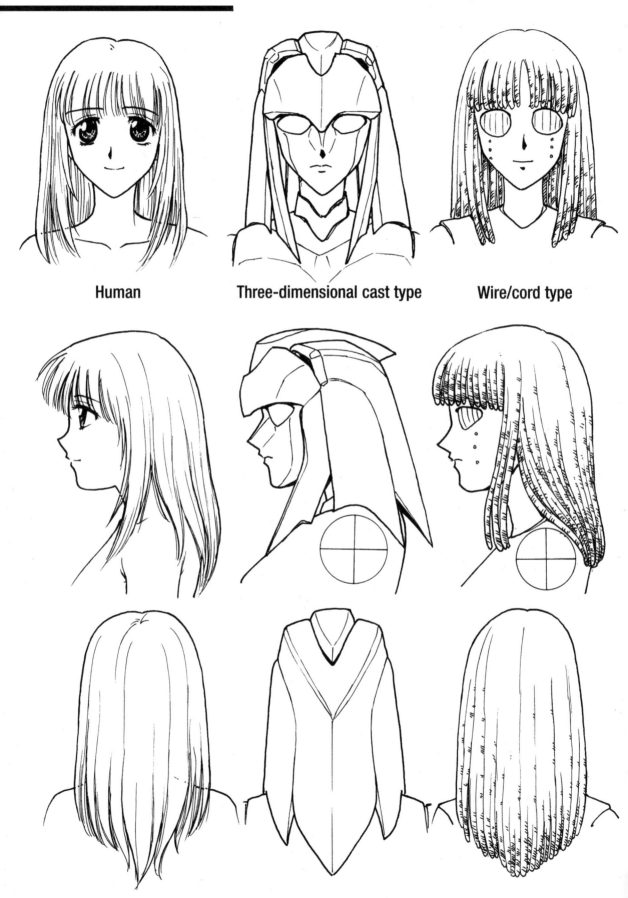

Human

Three-dimensional cast type

Wire/cord type

Human

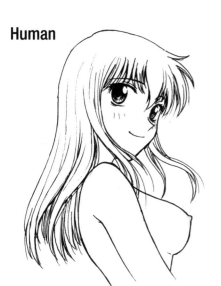

Wire/cord type

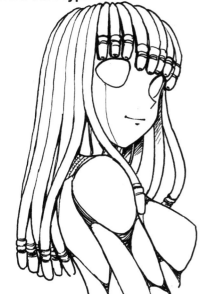

Movable block type

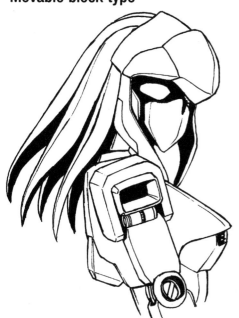

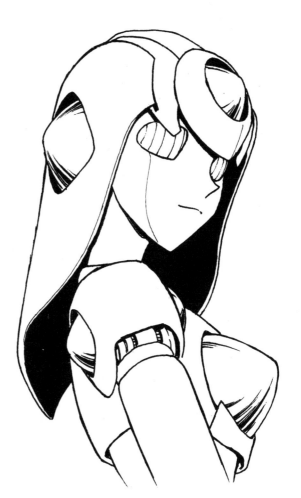

Three-dimensional cast type

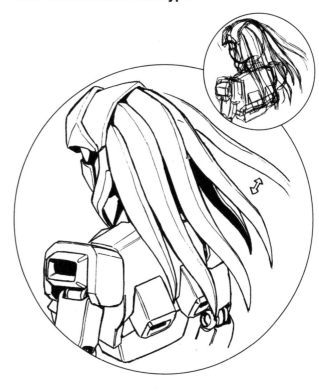

Designing Body Parts

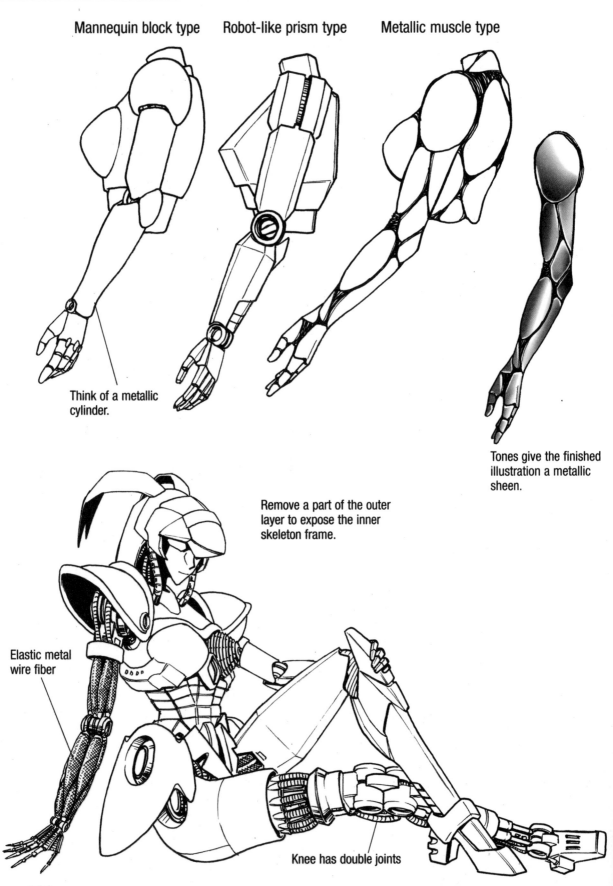

Mannequin block type

Robot-like prism type

Metallic muscle type

Think of a metallic cylinder.

Tones give the finished illustration a metallic sheen.

Remove a part of the outer layer to expose the inner skeleton frame.

Elastic metal wire fiber

Knee has double joints

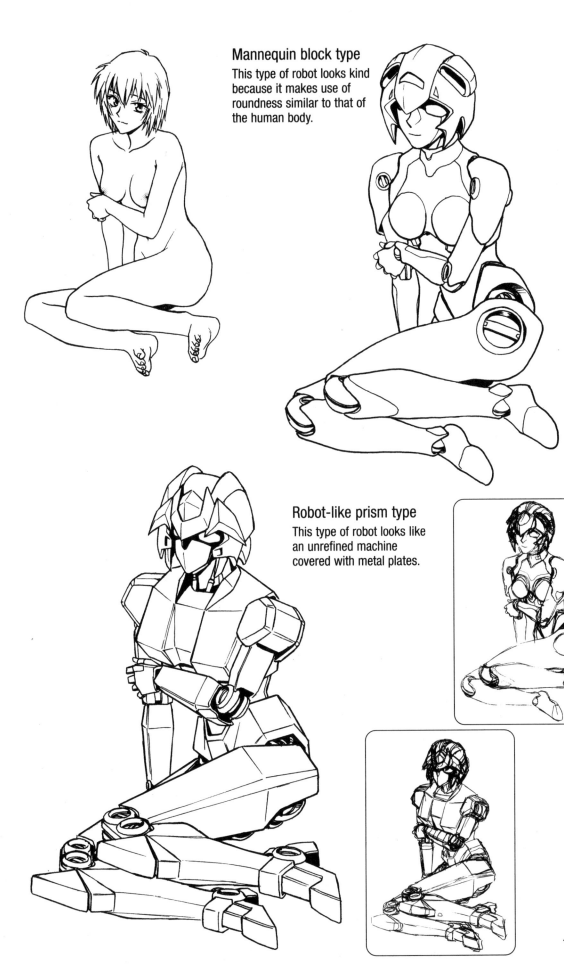

Mannequin block type

This type of robot looks kind because it makes use of roundness similar to that of the human body.

Robot-like prism type

This type of robot looks like an unrefined machine covered with metal plates.

Design Based on Fashion

Underwear and Body Suit Lines

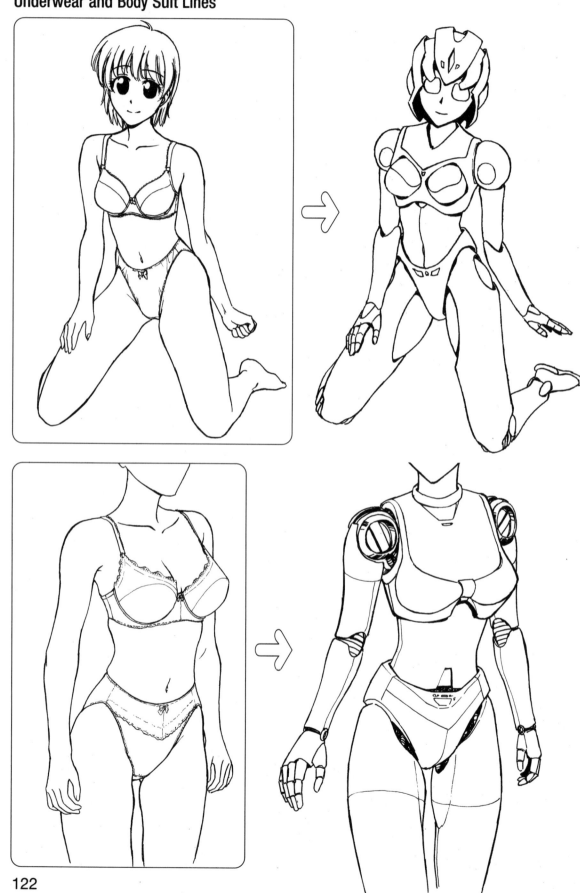

Bunny Girl Motif

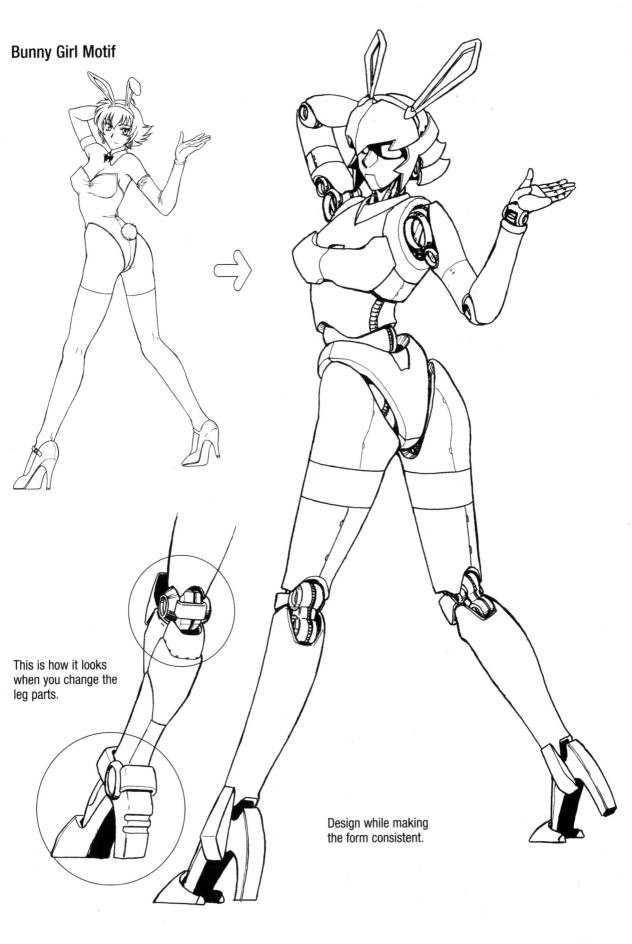

This is how it looks when you change the leg parts.

Design while making the form consistent.

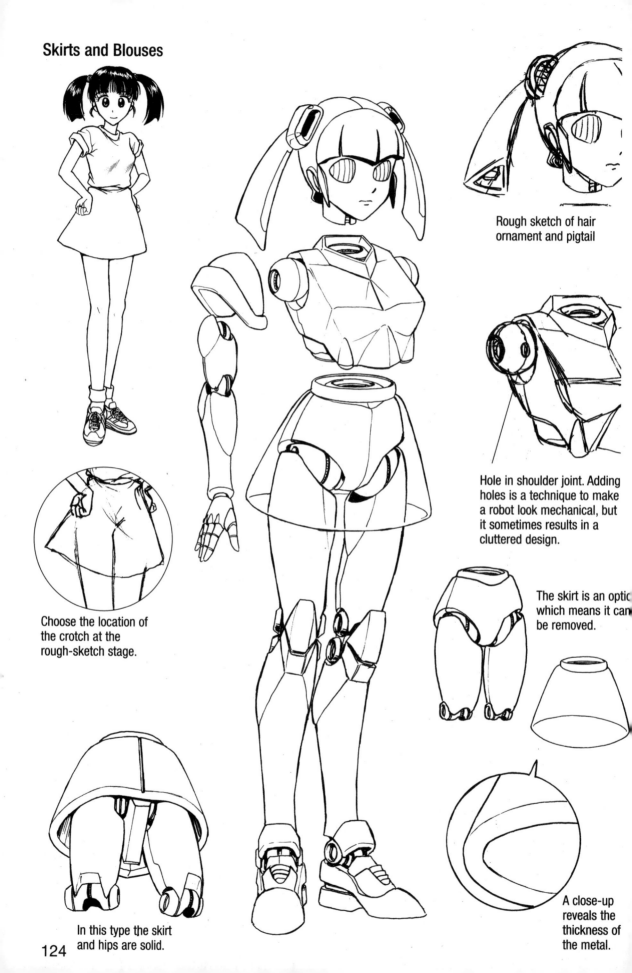

Skirts and Blouses

Rough sketch of hair ornament and pigtail

Hole in shoulder joint. Adding holes is a technique to make a robot look mechanical, but it sometimes results in a cluttered design.

Choose the location of the crotch at the rough-sketch stage.

The skirt is an optic which means it can be removed.

In this type the skirt and hips are solid.

A close-up reveals the thickness of the metal.

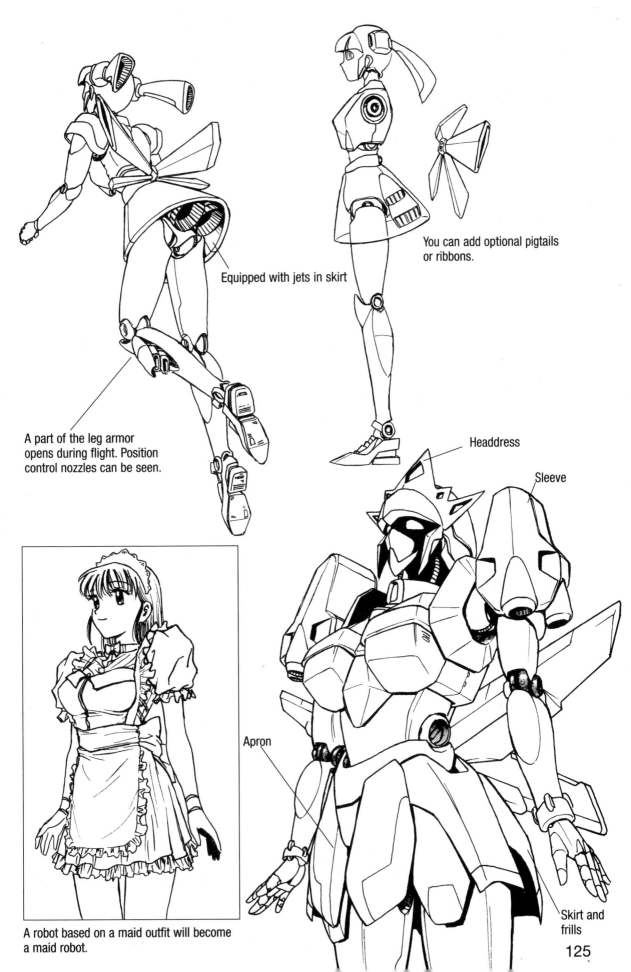

Equipped with jets in skirt

A part of the leg armor opens during flight. Position control nozzles can be seen.

You can add optional pigtails or ribbons.

Headdress

Sleeve

Apron

Skirt and frills

A robot based on a maid outfit will become a maid robot.

A Character Done in Metallic Will Become a Robot. Drawing reflections on skin (solid shading) and applying gradation tone will create the feel of a robot.

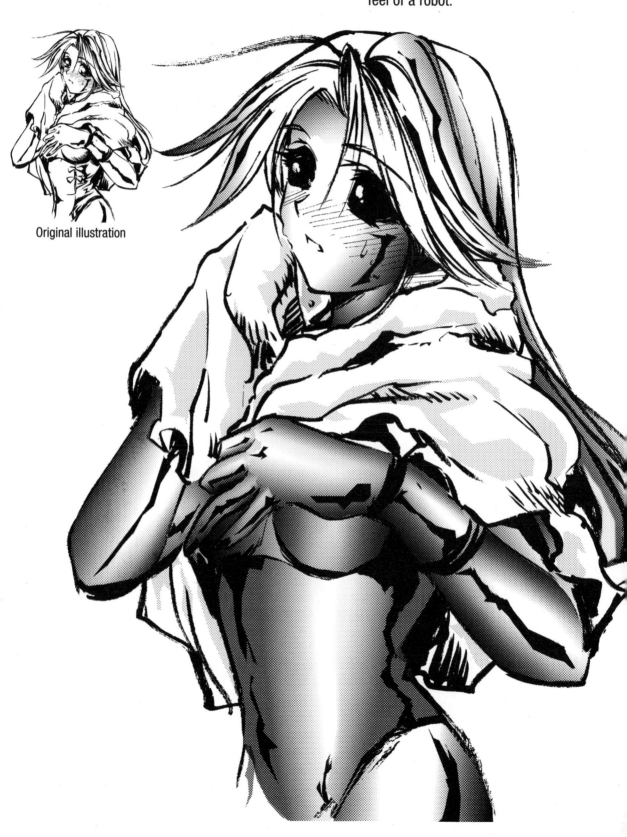

Original illustration